C000176132

EAST GRINSTEAD

THROUGH TIME

Dorothy Hatswell
& Simon Kerr

AMBERLEY PUBLISHING

East Grinstead Museum

The museum started life in the servants' quarters at East Court, eventually opening in 1925 in the former auction rooms on Cantelupe Road. Its collection amalgamated three sources of material. The first was the collection amassed by the vicar of St Swithun's, who added items of local interest he came upon. The church tower had been used for many years as the repository for fire engines. The Town Council, occasionally, were also given articles. The third source was the East Grinstead Society, formed to protect our historic town. All three collections were donated to the newly formed museum in 1976, and are still the backbone of our collection today.

First published 2013

Amberley Publishing
The Hill, Stroud, Gloucestershire, GL5 4EP
www.amberley-books.com

Copyright © Dorothy Hatswell & Simon Kerr, 2013

The right of Dorothy Hatswell & Simon Kerr to be identified as the Authors of this work has been asserted in accordance with the Copyrights, Designs and Patents Act 1988.

ISBN 978 1 4456 1836 4 (print)
ISBN 978 1 4456 1843 2 (ebook)

British Library Cataloguing in Publication Data.
A catalogue record for this book is available from the British Library.

Typesetting by Amberley Publishing.
Printed in Great Britain.

Introduction

East Grinstead as a town did not feature in the Domesday Book, written at the request of William the Conqueror in 1086. The name only appears as a 'hundred', a division of the county into smaller, administrative areas. The church that existed on the ridge, upon which the town would be built 100 years later, was then just the focal point for the manors surrounding it. Gilbert D'Aquila was a descendant of one of the French noblemen who accompanied William to England and were rewarded by gifts of land in Sussex. The county was divided into six strips, running from the coast to London, called 'rapes'. East Grinstead was in the Rape of Pevensey, arguably the most important, as it was on the direct route to the capital and included their landing place at Pevensey Bay.

D'Aquila built his town to a strict plan. The houses were set out on either side of a very wide road running in front of the church. This allowed markets and fairs the space to operate. The timber-framed houses were each 33 feet (around 10 metres) wide and had a long garden, or 'portland' behind them. This meant that the people who lived in them, mostly working in the timber or leather trades, could be largely self-sufficient. They would grow vegetables and fruit, keep a beehive, chickens for meat and eggs, and probably a pig. The houses from that early period have not survived but they were gradually replaced in exactly the same positions by others, which date from the fourteenth and fifteenth centuries. St Swithun's church has also been replaced at least twice. The present church was built in 1810, necessitated by the collapse of the tower of its predecessor.

East Grinstead grew slowly in importance over the next nine centuries. It was a natural staging post, as it is halfway between London and the South Coast. Coaching inns flourished and the town prospered. Assizes were held here, particularly in the winter when the notorious Sussex clay turned roads into quagmires, and magistrates and lawyers from London found it almost impossible to penetrate further into the county.

The Turnpike Act of 1729 alleviated some of the problems with the roads and increased traffic through the town, but the relief lasted little more than a century. The coming of the railways, particularly the line through Three Bridges, drew long-distance traffic away from the roads and on to the rail. East Grinstead suffered a period of decline, but in 1855, as a result of the persistence of a group of local residents, a link to the Three Bridges was opened. The town then expanded. The ease of travelling to London meant that the wealthy bankers and

businessmen could work in London and travel home each evening. Their families had the benefits of the clean air of the countryside, and had large houses built for themselves in the land around the town. They needed servants, who in turn began to need small houses themselves. Rows of terraces sprang up to accommodate them. They also needed shops, so the High Street now converted the artisans' premises into retail outlets. These in turn needed staff and the growth of the town was assured.

This process continued up to the First World War, which was a period of stagnation everywhere. Hundreds of men went to fight in France, Italy and Gallipoli, many of whom did not return. After the war, the whole county was in the grip of a depression that lasted most of the inter-war years. There was short period in the mid-1930s when two local businessmen seized the opportunity to develop the area at the northern end of the London Road. It provided employment for local workers at a time when work was scarce.

The Second World War did nothing to improve the town, but the coming of peace did. The returning servicemen and women had tasted freedom and did not want to return to service in the big houses. The large estates could not be sustained without large numbers of staff, so one by one they were sold for development. The first were Imberhorne and Halsford to the north of the town centre. This trend continued with the Herontye and Woodbury estates on the eastern fringe of the town. Now developments are smaller and are infilling on large, individual gardens. Without a change in the planning laws, both from the Government and from the Conservators of Ashdown Forest, it is doubtful that any significant further expansion can take place in the near future. The town is recovering from the closure of small shops during the recent recession and the arrival of the Bluebell Railway earlier this year will encourage more tourists. The future seems assured.

We must thank Sheila Fenning, Jonathan Parrett and Sarah Francis for their technical assistance on this project, and Olive Coombe and Chris Allen for proofreading and general advice. Our greatest gratitude, however, is to David Gould. Without his knowledge, both of the museum's collection of photographs and of East Grinstead itself, this book would have been impossible to write.

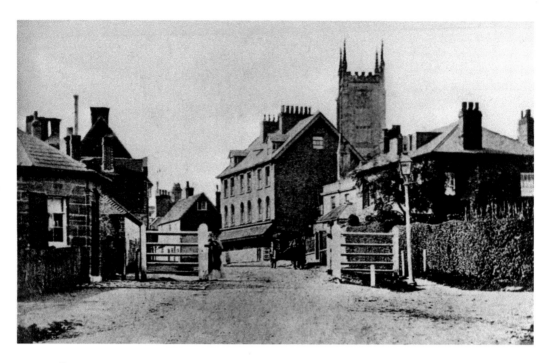

Toll Gate

The road through East Grinstead was turnpiked in 1717. Toll gates were erected to the east of Sackville College. Turnpiking gave a board of trustees the responsibility for maintaining the surface. The money for repairs came from the tolls collected by the toll-keeper. Charges varied from 1*d* for every horse, to 6*d* for coaches. The keeper lived with his family in the small octagonal building, often supplementing his income by selling sweets. The gate was removed in 1864 when the Turnpike Trust was wound up.

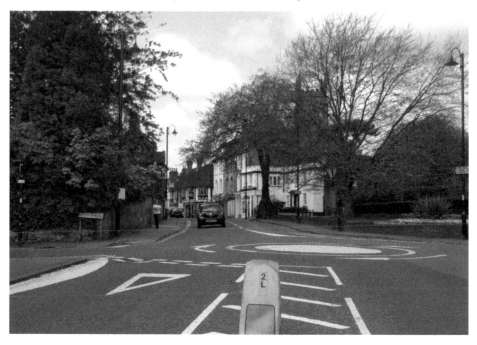

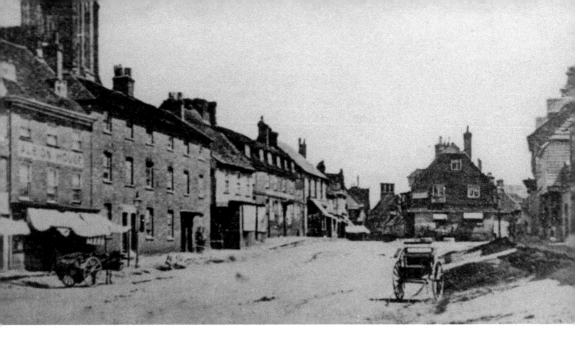

High Street, 1864

This earliest known photographic view of the High Street looking east shows a strangely empty scene to modern eyes. The road surface is unmetalled, the advent of the motor car still some thirty years hence. The main transport of the period was the cart, drawn by horses, donkeys and even oxen. The one on the left is a handcart. Cantelupe Road has not yet been punched through, but the narrow entrance to the stables behind the Crown can just be detected.

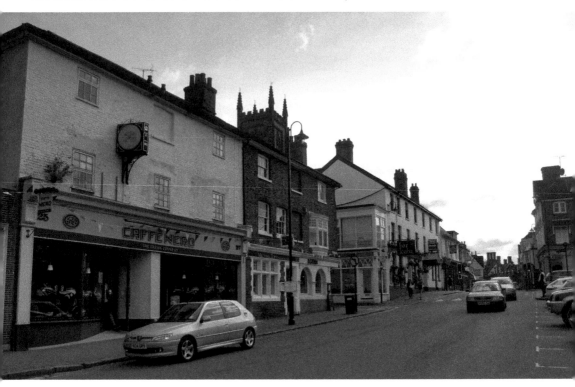

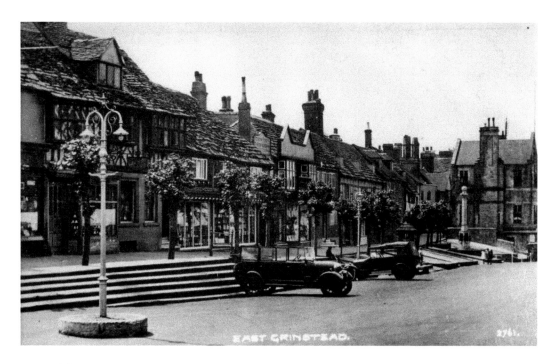

High Street

The avenue of pollarded lime trees, which were planted in 1874, enhances the southern side of the High Street. The photograph predates the war memorial, which was dedicated on 23 July 1922 to the men of East Grinstead who fell in the First World War. The decorative wrought iron lamp-post has long since vanished. The scene, however, is still largely unaltered thanks to the vigilance of the East Grinstead Society, who pressed for the High Street to become a conservation area and have kept a watching brief ever since.

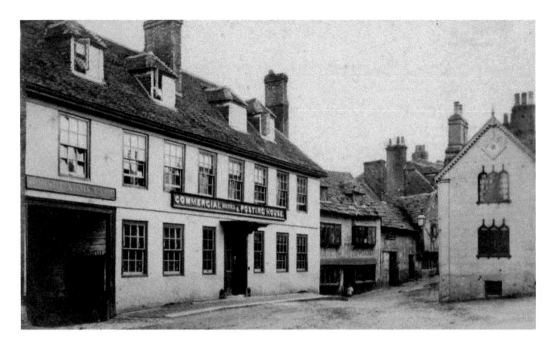

Dorset Arms

The Dorset Arms was an important staging post on the route from London to the South Coast. It has had several names in its long history, being initially called 'The Newe Inn', then 'The Catt' and 'The Ounce'. The last two names refer to the leopard supporters on the arms of the Earls of Dorset. Today it is still an inn. It is also one of the few places where the long portlands behind the building can be seen.

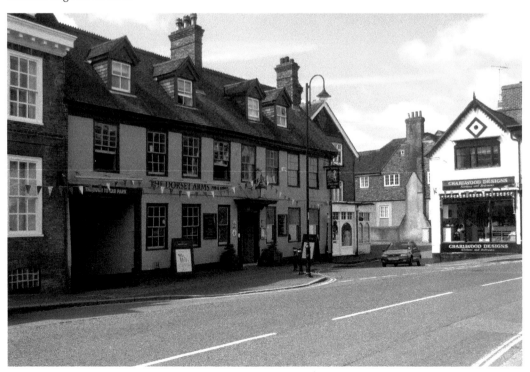

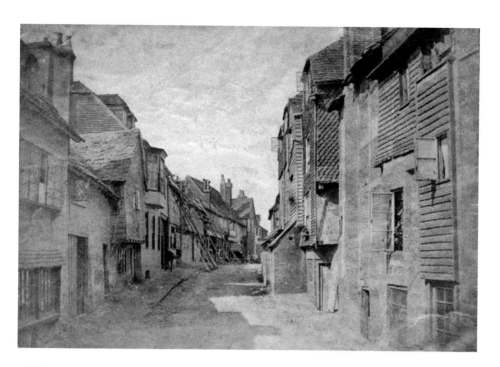

Middle Row

Middle Row started life when the row of stalls outside the church expanded on to the middle of the road. They gradually became more permanent structures and formed the island we see today. This view along the back of Middle Row shows it slightly down at heel. This is an early photograph, which was taken when the town had not fully recovered from the period of decline brought about by the loss of demand for the stagecoaches which once brought prosperity to the town.

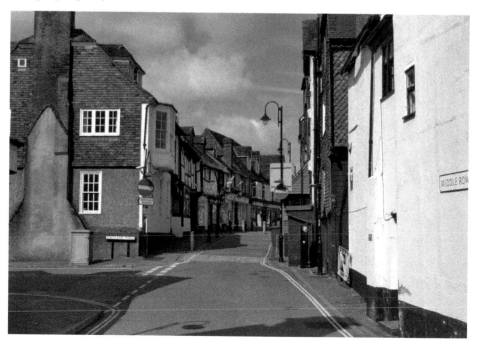

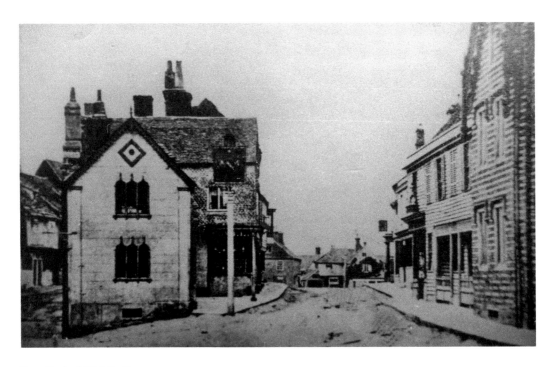

East End of Middle Row

The building with the white gable was occupied by Thomas Palmer. He had multiple interests in the town, and this is where he sold his quill pens. The windows of the shop were shaped as nibs. He obtained a Royal Warrant through a chance purchase from a man who was staying in the Dorset Arms. Since then, many businesses have used the premises. They occupy a prominent position. The present incumbents, Charlwood Kitchens, have traded there for around twenty years.

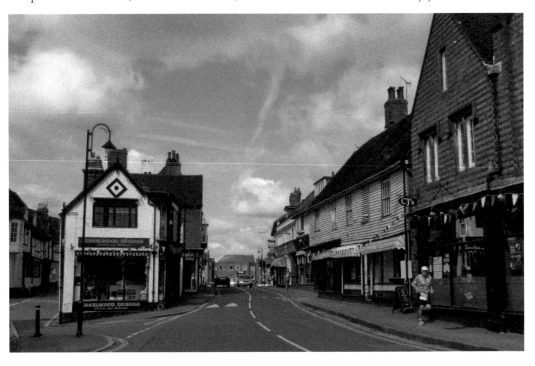

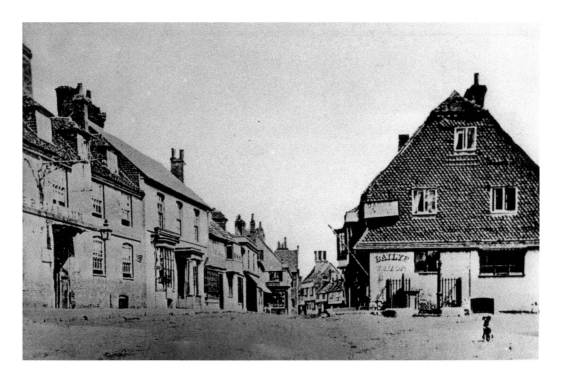

West End of Middle Row

This view of the High Street shows the west end of Middle Row, with the premises of Bailye, the tailor and barber. The Midland Bank occupied the building for a number of years. When it closed, it was converted into a café called Casablanca, with residential flats above. On fine days, tables are put on the paved area in front. How many people enjoying their ice creams realise that they are probably on the site where three people were burned to death as martyrs in 1556?

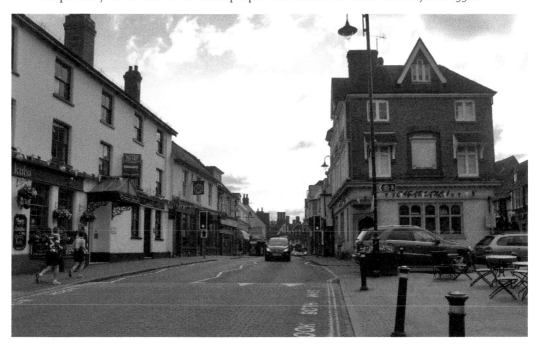

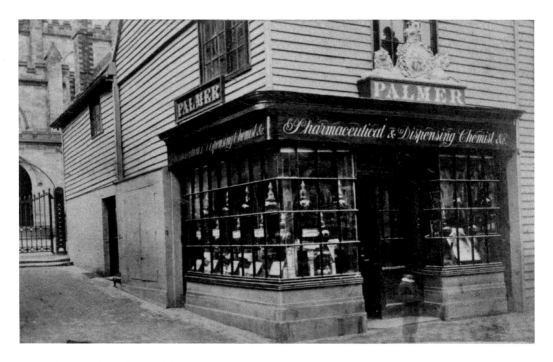

Palmer's Chemist's Shop, High Street

Thomas Palmer, senior and junior, were entrepreneurs in the late eighteenth century. Thomas senior was the master at Payne's Grammar School. He soon branched out. He was an agent for the Phoenix Insurance Co. and Postmaster, as well as opening this chemist's shop in the High Street. After his death, his son took W. H. Dixon as a partner, who eventually took over. He moved to Railway Approach. The shop at the entrance to the churchyard was purchased by an Indian restaurant, The Monsoon.

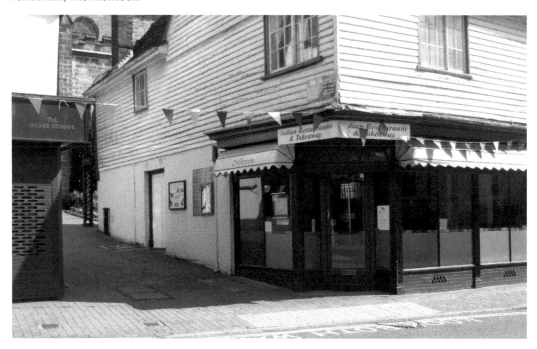

Wilcox's Saddler's Shop

In 1858, the then owner let the premises to the Sisters of St Margaret. By 1881 the shop was occupied by Francis Wilcox, saddler. His advertisement in the 1896 Directory claims 'Thirty years of experience in all branches of the trade.' His wife was a dress and mantle-maker and made the riding habits for their shop. The saddlery business continued until the 1950s. Since then the property has been in several hands. Today it is a florist's shop, delightfully named The Daisy Chain.

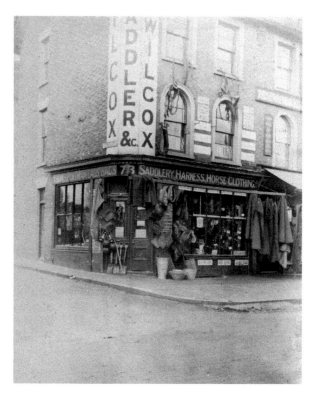

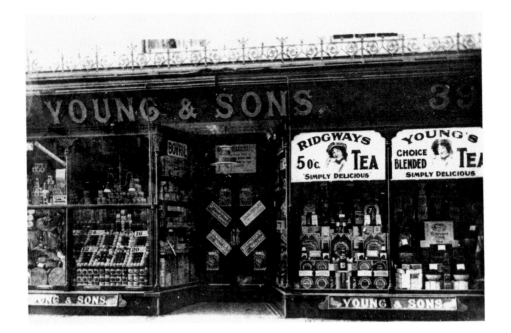

Young's

The very well patronised grocers in the High Street were Young & Sons. They also had a flourishing ladies' clothing and haberdashery department in their other shop a few doors down. They had purchased it from the Burt brothers, who had operated their bank from the premises since 1810. In the early 1920s, Young's sold the shop to A. J. Coatman, who took it over as a going concern and ran it for another fifty years. Nowadays, Pizza Express is equally well patronised.

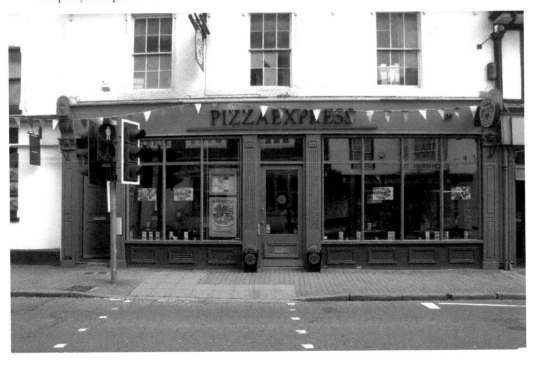

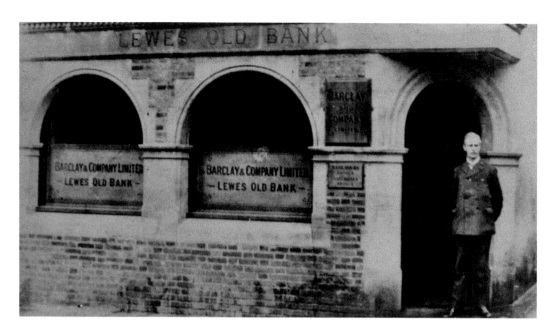

Lewes Old Bank

John Head started this bank and in 1870 was succeeded by his grandsons. Later George, a great grandson, took over. The bank failed in 1892, leaving individuals, businesses and the Cottage Hospital without funds. However, after the bank's finances were finally wound up there was some money left for its creditors. Several businesses have used the premises since then. The present owners run a restaurant called Agora. Unfortunately, the original lettering on the façade has been covered by their sign.

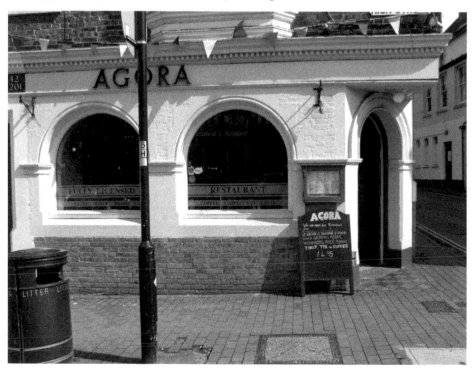

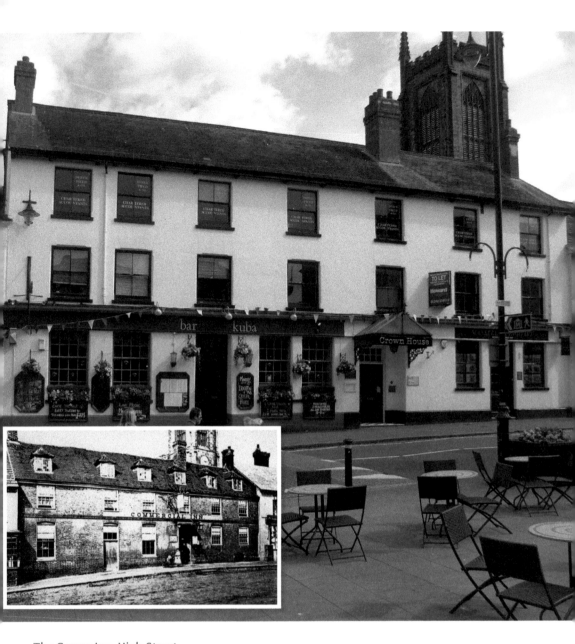

The Crown Inn, High Street

The Crown is the oldest inn in East Grinstead. Originally timber-framed, it was rebuilt around 1800. It was the headquarters for many of the societies in the nineteenth century, and the Magistrates Court was also held there. In 1885 it was the first inn to install electric light. It was popular with commercial travellers, hence the name on the frontage. When it changed hands earlier this century, it was renamed the Bar Kuba. While the name has no relevance to its history, it remains very well patronised.

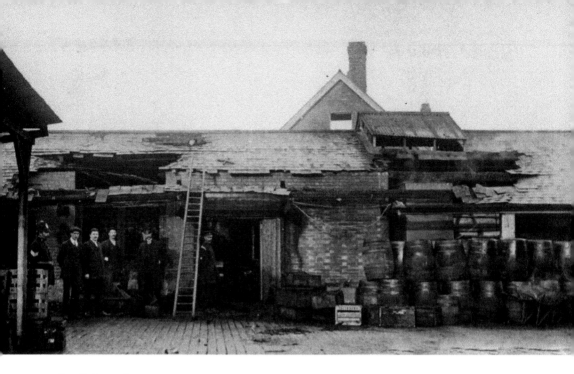

Southdown Brewery

The Southdown & East Grinstead Brewery took over the Hope Brewery in 1895. The name 'Hope' dates back to 1839. In 1844 it was catalogued as 'built within the last few years'. When it closed in 1920, it was adapted for offices. Although the building no longer exists, some of their bottles survive in the East Grinstead Museum. Our latest fire station is on the site now. Their open days are eagerly attended by children, who are allowed to sit on the fire engine.

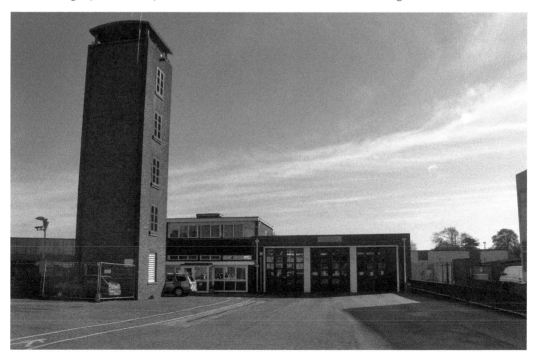

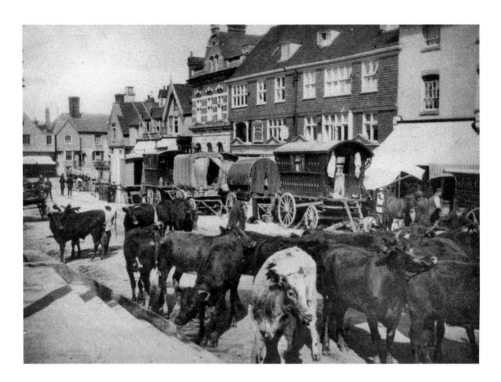

Market in the High Street

In 1247 a Royal Charter was granted to the Lord of the Manor for the right to hold a fair every Monday, and also one lasting two days, on 24 and 25 July. Fairs and markets were held in the High Street until the 1950s when they transferred to Cantelupe Road. This scene shows a fair, with a cattle market, in the 1930s. The animals appear to be free to wander at will. The opposite side of the road is lined with travellers' traditional caravans. Today, there are parked cars!

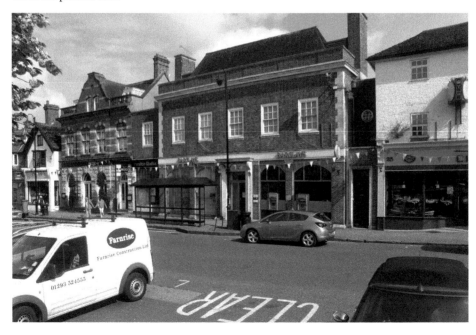

Cantelupe Road Market

This weekly market for livestock and general trading was started by auctioneers Turner, Rudge & Turner. The agricultural building in the background was where the auctions were held. It closed in the 1990s. It was purchased by the East Grinstead Town Council and given to the museum, which needed a larger and more convenient location. Heritage Lottery funding was obtained and this purpose-built museum opened in 2006. It stands on the exact footprint of the auction house which preceded it.

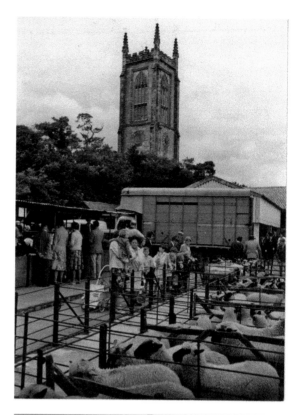

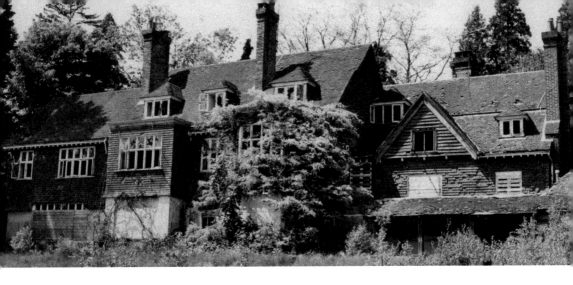

The Hermitage

The earliest reference to this house is in 1780 when it was owned by Thomas Wakeham. He sheltered Jane Wilson when she was sent to East Grinstead to prevent her from marrying Spencer Perceval, then a struggling lawyer. He followed her and they were married in St Swithun's church. He became an MP, and later Prime Minister. Their union was blessed by twelve children. Perceval was assassinated in the Houses of Parliament in 1812, thus acquiring the dubious distinction of being the only British Prime Minister to suffer this fate.

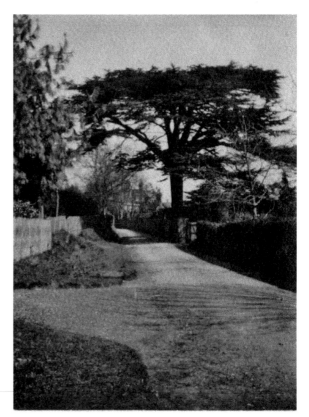

Hermitage Lane

The south end of Hermitage Lane in around 1908. The road was named after a house called The Hermitage owned by a local solicitor, Thomas Wakeham. In 1564 it was known as Hollow Lane. Edward Sherman was the brewer in 1659. Though it was possibly renamed Brewhouse or Brewers Lane at this time, there is documentary evidence that it had this name between 1780 and 1872. The brewery stood at the top of the lane on the right-hand side.

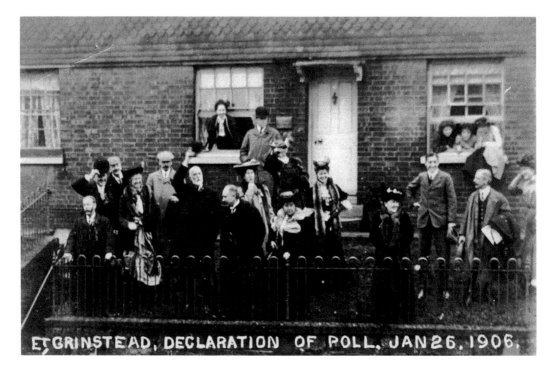

E.GRINSTEAD, DECLARATION OF POLL, JAN 26, 1906.

Rock Gardens, London Road

This row of cottages stood in an elevated position on the eastern side of the road. Election results were traditionally announced there. The photograph shows the Declaration of Poll in 1906, when Charles Corbett, the Liberal candidate, was elected. It is the only occasion when East Grinstead has returned an MP who was not a Conservative. Christopher and King purchased the site in the early 1930s. They reorganised the whole of this area and the Rock Gardens were subsumed into their grand plan.

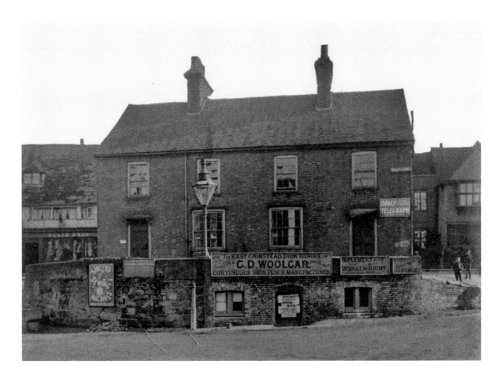

Round Houses

This island site was once occupied by a forge dating from 1475. The back-to-back Round Houses were built in the eighteenth century. Around 1860, there was a butcher's shop, a grocery run by a widow, a Dame School and two sisters who were dressmakers there. The houses were derelict by 1890. In 1893 they were superseded by the Constitutional Club, designed by an unknown architect as the result of a competition. The balcony, approached from an external staircase until 1930, was used to announce election results. It is now occupied by several businesses.

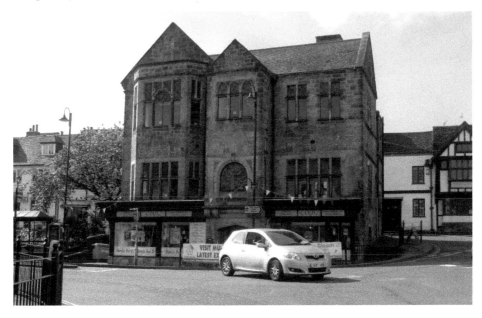

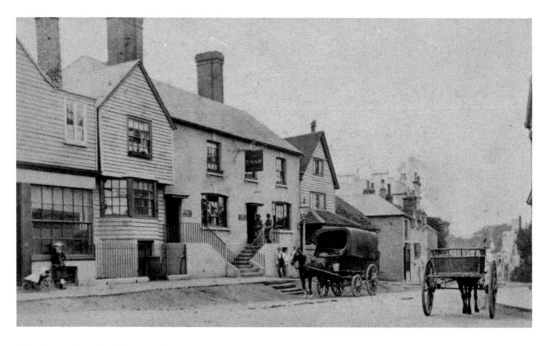

The Swan Inn, London Road

At the end of the nineteeth century, the Swan Inn was one of many public houses in the town. Standing in London Road, near the junction with the High Street, it is first mentioned in 1709. In the 1886 Directory it is described as a 'Family and Commercial Hotel' with 'Good stabling, loose boxes and lock-up coach houses'. The proprietor was Mrs S. Draper. In 1963, the site, along with its neighbours, was demolished to make way for a new development seen here.

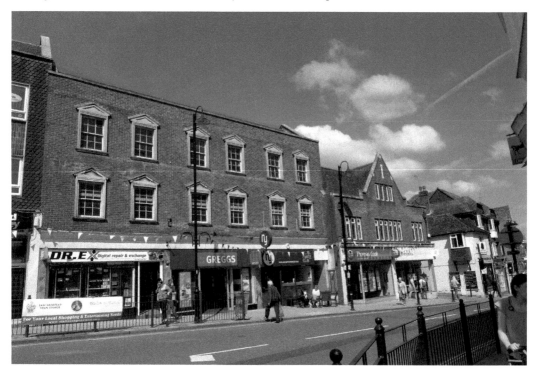

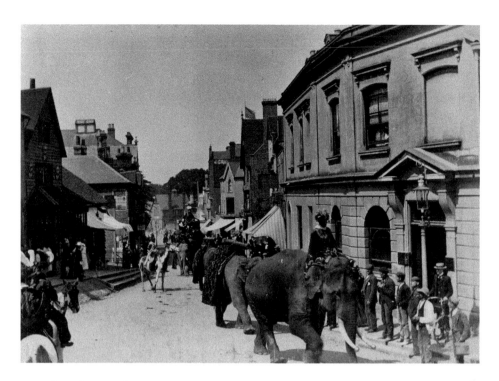

Top of London Road

A busy scene at the top of London Road. The Swan Inn on the left is doing a roaring trade. The elephants are advertising that the circus has arrived. It is recorded in one of the local schools' logbooks that the children were allowed home early to see it. The present day scene has altered, insofar as the shops have changed hands and the Swan has gone; otherwise the top of the London Road is still recognisable today.

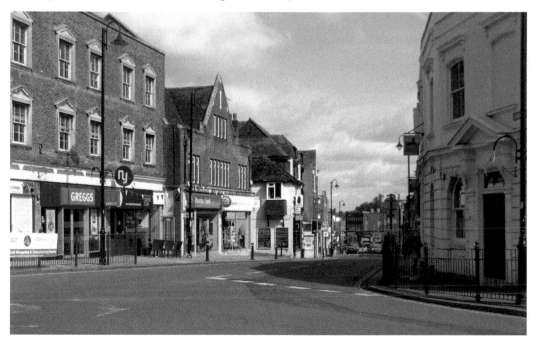

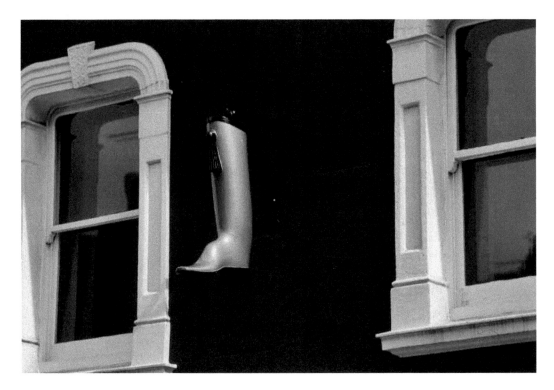

Golden Boot

A familiar sight in the London Road, until recently, was this magnificent boot. Carved from wood, standing over a metre high, it has hung outside shoe shops in East Grinstead for many years. The earliest-known shop it graced was in the High Street. Thrown on a rubbish heap, it was rescued by a Mrs Webster. It has also been displayed in Cantelupe Road and Railway Approach. The most recent owners were Russell & Bromley. Now the branch has gone, it is being preserved in that company's headquarters.

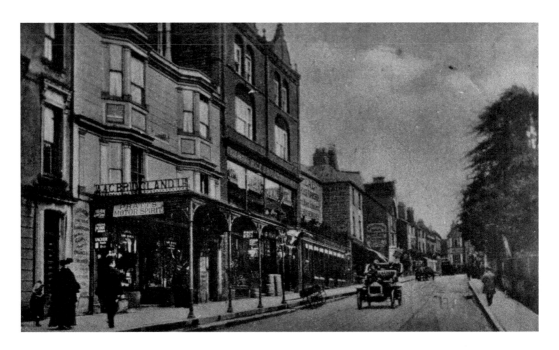

A. & C. Bridgland Ltd

Established in 1840 by James Bridgland, this was a family firm that flourished into the 1980s. Initially in the High Street, it moved into London Road in 1887. Their ironmongery business was built on the site of the old workhouse in 1864. The 1891 census shows Charles aged twenty-seven, an ironmonger, living there with his wife Eugenie. He is the 'C.' of 'A. & C.'; his brother, Alfred, was his senior partner. The premises were destroyed in 1944 when the doodlebug fell on London Road.

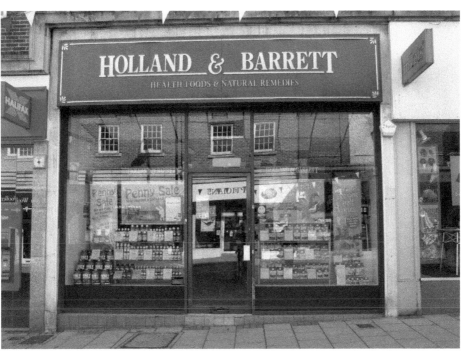

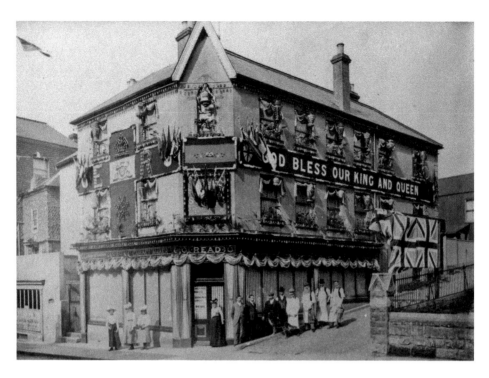

Read's Furniture Shop

At the foot of Rice's Hill stood Read's furniture shop. Pictured here, decorated to celebrate the Coronation of Edward VII and Queen Alexandra in 1902, the corner of the wall around the Wesleyan chapel can be glimpsed on the right. Their furniture vans, with their name boldly inscribed on the sides, were once a familiar sight around the town.

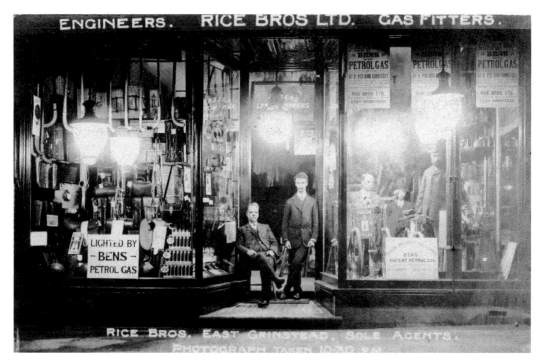

Rice Brothers

The Rice family played an important part in the history of East Grinstead from the mid-nineteenth century for over 100 years. Joseph Rice was a prominent businessman and also served as chairman of the Urban District Council for some time. Here, their shop in London Road is proudly proclaiming that they were the first business in the town to be lit by the newly available gas. As seems to be the fashion of the period, the owner and staff pose for their photographs outside.

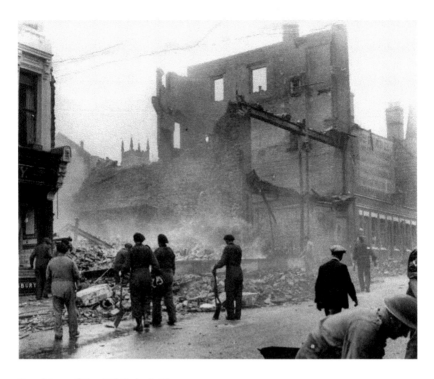

Bombing of the Whitehall Cinema, 1943

The aftermath of the bombing of East Grinstead on 9 July 1943. A stick of 6 bombs claimed the lives of 108 people, mostly in the Whitehall Cinema. It was five o'clock and a 'Hopalong Cassidy' film was showing. Over forty children were among the dead. The rest were Canadian troops stationed nearby and cinema staff. A lone German bomber, turned back by anti-aircraft fire from London, followed the railway to East Grinstead and discharged his load there. It was the worst incident in Sussex during the Second World War. The façade of the Whitehall Cinema survived.

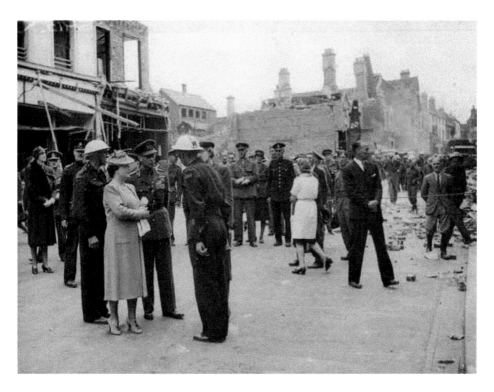

Bombing, 1944

Lightning may not strike twice in the same place, but the Luftwaffe did in London Road in East Grinstead! Almost exactly a year to the day after the terrible event of 9 July 1943, a doodlebug landed in almost exactly the same place. Luckily, it was early in the morning, otherwise the casualty figures might have been as high as before. King George VI and Queen Elizabeth were in the area later that day and visited the scene to extend their sympathy.

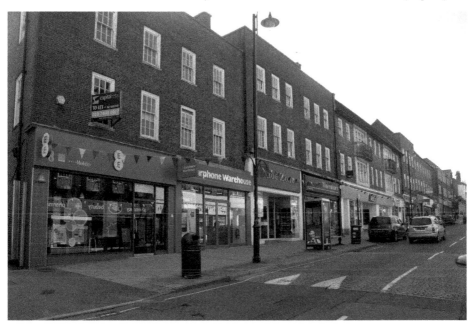

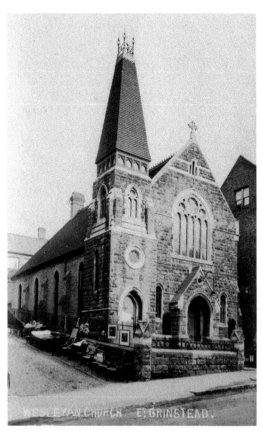

Wesleyan Chapel

This Wesleyan chapel stood in the London Road to the right of Rice's Hill. The hall behind was destroyed on the night in 1943 that the Whitehall Cinema was bombed. Fortunately, the chapel itself was untouched and survived for another few years. A branch of WHSmith's is now on the same corner.

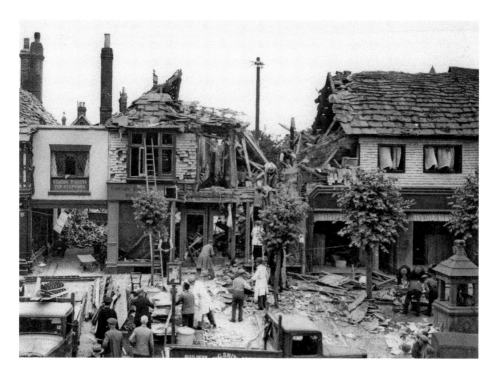

Brooker Brothers' Bomb

Tooth's stationery and bookshop in the High Street was spared in July 1943 when the bombs fell. The owners, Edwin Tooth and his wife, were killed by the blast as they sat in their garden. The building next door, Brooker Bros, the builders, took a direct hit. The last bomb dropped harmlessly in the grounds of Herontye House. The premises were rebuilt after the war and are now used by an estate agent.

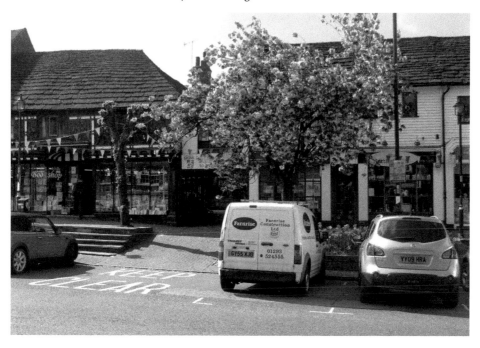

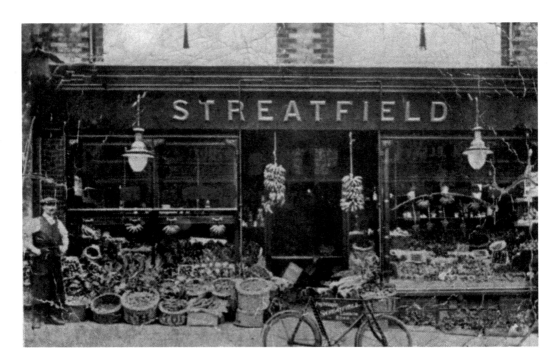

Streatfield's Shop

This family greengrocer's shop was at No. 32 London Road. The Streatfields were a well-known and respected family of traders in the town. Their business here started around 1912 and did not close until 1935. They also owned another shop further along London Road, which was closed during the First World War owing to the fact that all the men had been conscripted. The shop is now a branch of The Edinburgh Woollen Mill.

H. W. Ledger
No. 62 London Road, in around
1927. Herbert Ledger stands proudly
outside his drapery and haberdashery
business with his wife and staff. He
had purchased the shop from Frank
Blanchard in 1926. Mr Blanchard had
been there for twenty years. Ledger's
was closed in 1953 and taken over by
Radio Rentals until they, too, closed
in the 1980s. The premises are now
occupied by Phones 4u.

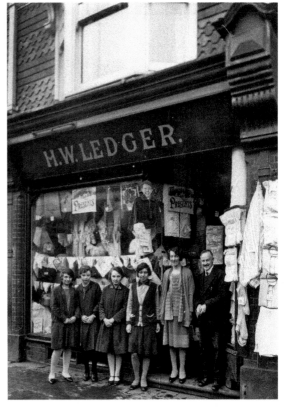

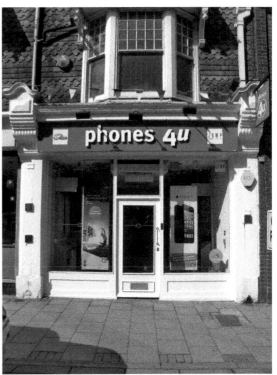

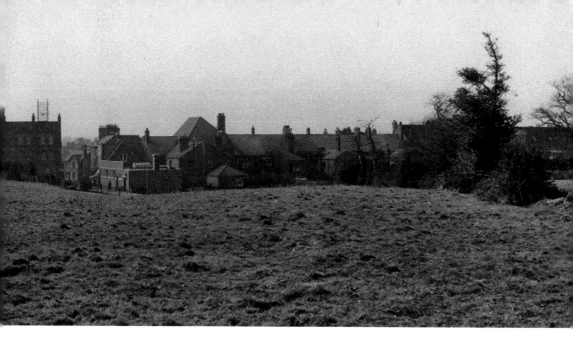

Path Across Field, 1934

This view, looking towards the old post office, was taken in 1934. It was just prior to the development of the Christopher estate. The strange, ladder-like object rising above the building is the aerial of the telephone exchange. The backs of the buildings to the right are along the London Road. When Christopher and King developed the area in 1935, the land was used partly for building and partly for the car park, which now occupies the majority of the site.

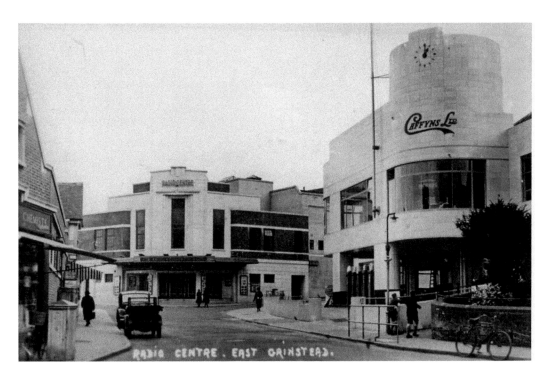

King Street

King Street was laid out in 1935/36. The cinema and garage were designed in the Art Deco style. The cinema had a very glamorous interior. It was named the Radio Centre, echoing the Radio City Music Hall in New York. This beautiful scene no longer exists. The cinema closed in 1989 and was demolished and replaced by a multi-screen cinema, The Atrium. Caffyn's Garage closed in 2006, and despite several schemes to redevelop the site, it remains a sad reminder of its former glory.

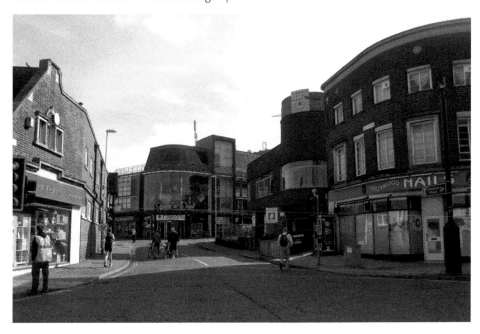

Jubilee Institute

This building was opened in 1888, commemorating the Golden Jubilee of Queen Victoria. It contained a lending library and coffee bar. The first manager was William Harding, a local photographer. It enjoyed a reputation for good food, which continued with the next manager, William Bright. It was flattened in 1938 as part of the redevelopment of the area. The clock, in honour of Thomas Cramp, the teetotaler, was repositioned on a pillar nearby. Hollywood Nails are now running their salon there.

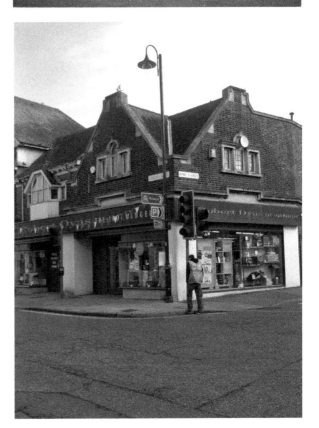

Boots

This shop was built as part of the Christopher estate in 1936, on the corner of the newly created King Street (named after Christopher's business partner, Harry King, not the monarch, George V). It was a standard shop building of the period, although the developers had designed other buildings on the estate in the then highly fashionable Art Deco style. Now in the hands of Robert Dyas, the ironmongers, it is still largely unaltered from the original design.

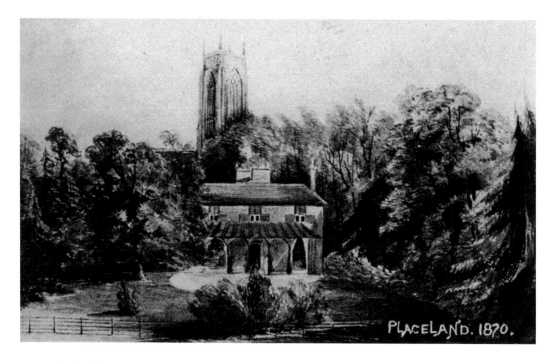

PLACELAND. 1870.

Placelands, London Road

Placelands was the home of Arthur Hastie, a well-respected solicitor and local benefactor. He was instrumental in the development of the railway line and improvements to the Cottage Hospital in the mid-nineteeth century. The house seems never to have been photographed. However, a watercolour of it does exist and is reproduced here. Engulfed by the Christopher estate, as was most of the open space nearby, this charming house seems to have disappeared, leaving only a painting to give a faint impression of its former glory.

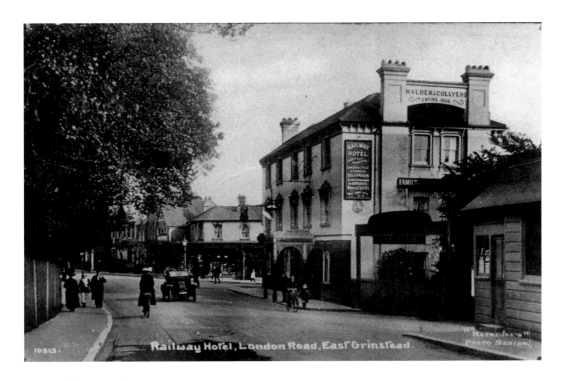

Railway Hotel

A peaceful London Road, almost devoid of traffic, with the Railway Hotel in 1923. It was a popular venue for cyclists. The group of elms in the garden of Placelands did not survive the development of the site, though at least they were spared the indignity of Dutch elm disease! The popular Broadway is on the site. The large area at the front is full of customers enjoying the sun, when it appears. It was first called 'The Glanfield', after its architect, a rather unusual tribute.

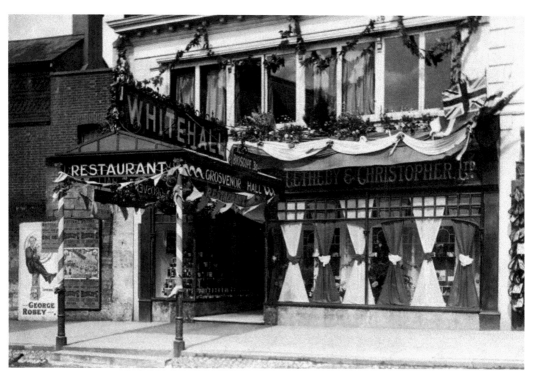

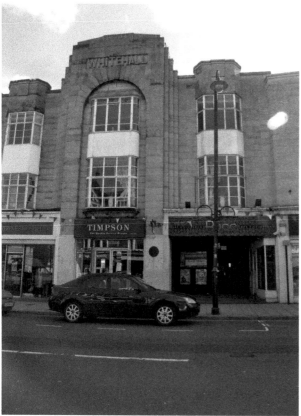

Grosvenor Hall
Decorated for the Coronation
of Edward VII in 1902, the
Grosvenor Hall was a popular
venue for the people of East
Grinstead. Opened in 1884, it
was the scene of many dinners,
dances and performances until
superseded by the Whitehall. It
even boasted a roller skating rink.
Earlier the site had been called
Bedlam's Bank, possibly because
the first workhouse was there.
Letheby and Christopher acquired
it in 1910 as a theatre, restaurant
and later, a cinema. It is now a
nightclub and shops.

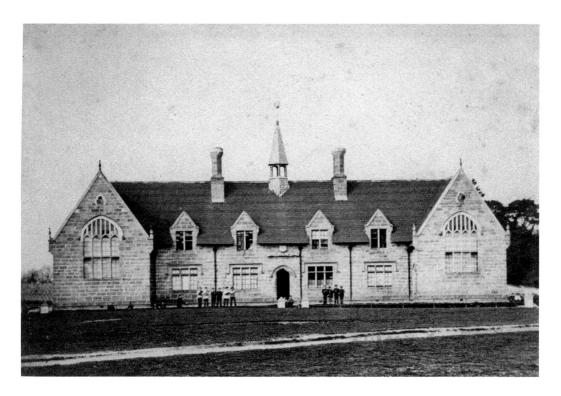

Chequer Mead

In 1861, Chequer Mead opened as a National School. Originally, the land formed part of Slaughterhouse Mead, but was named after the adjoining field. It underwent various changes in the ages of the pupils, but was eventually made redundant by the growth in population and the migration towards the outskirts of the town. It was purchased by the town council in 1990 and refurbished as an arts centre. A theatre was built behind. It is now a very vibrant centre for the arts in East Grinstead.

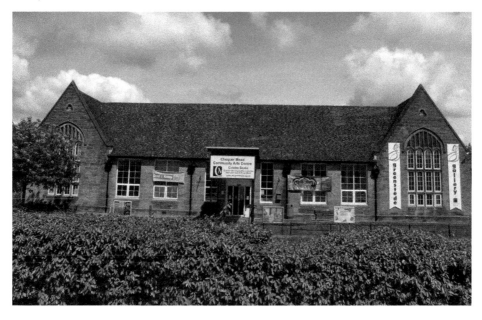

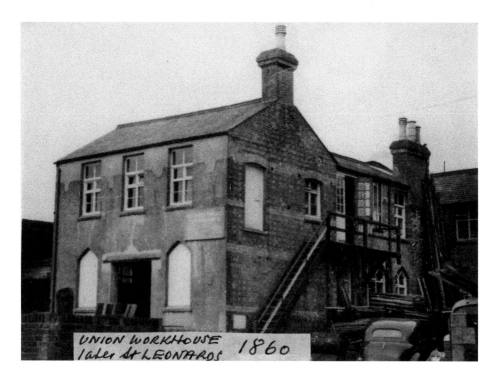

UNION WORKHOUSE
later St LEONARDS 1860

East Grinstead Workhouse

The workhouse was originally in the London Road. The Union Workhouse in Railway Approach was built in 1859. The 1871 census shows the workhouse master and his wife, who was the matron, with forty-eight inmates. It was later renamed St Leonard's. This forbidding building was the annexe on the opposite side of the road. Both were demolished in 1982. Blocks of flats were erected on the workhouse site amid well-landscaped grounds, retaining the name St Leonard's. The annexe has been replaced by the Mid Sussex Timber Yard.

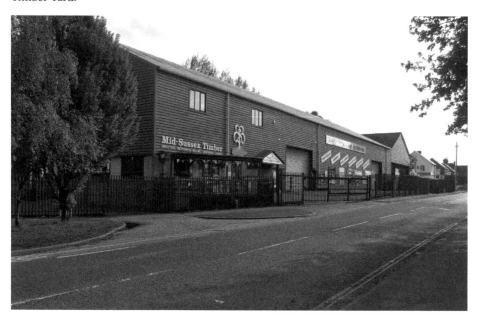

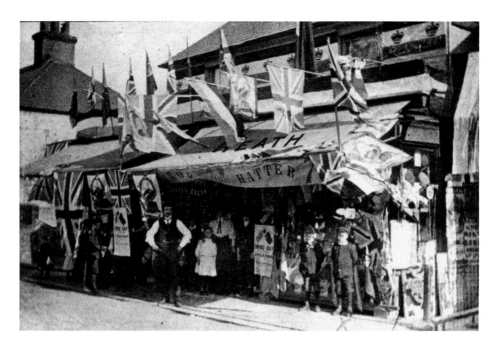

Heath's Hatter's Shop in Railway Approach

This photograph taken about 1907, shows Heath's bedecked with flags on Empire Day. Celebrated on Queen Victoria's birthday, 24 May, it was the occasion when the success of the British in conquering half of the globe was glorified. The British Empire was indeed 'the Empire over which the sun never sets', so widespread were the territories involved. Schoolchildren sang patriotic songs and they were given half a day's holiday. The site is now an open space on Railway Approach.

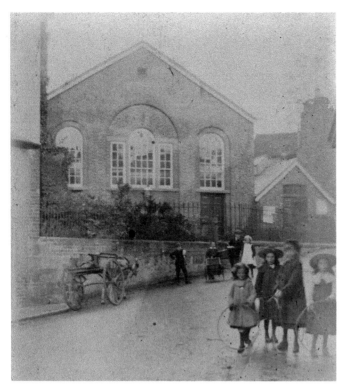

Zion Chapel

Built in 1810 by a Forest Row family, the Burts, Zion Chapel is the oldest Nonconformist place of worship in East Grinstead. The hall to the left started life in 1862 as a Calvinistic Methodist church. During the nineteenth century it was the centre of an almost alternative culture in both political and social, as well as religious areas. The Sunday school provided opportunities for an elementary education in a time before it was compulsory. Today, the chapel still flourishes and provides social and educational functions alongside its religious one.

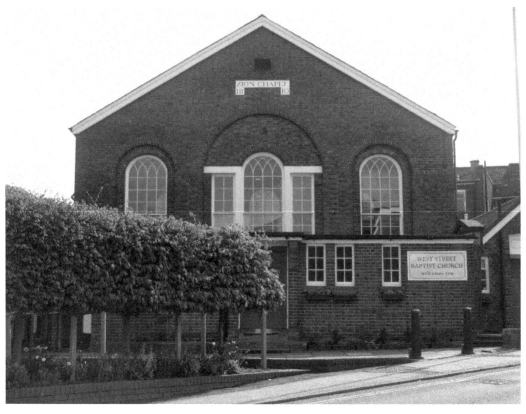

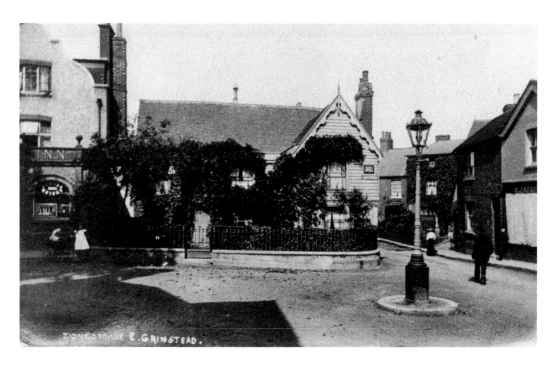

Zion Cottage

This attractive cottage, with its distinctive bargeboards, stood at the corner of Ship Street until its demolition in 1934. At first called Zion Cottage, it was later renamed Corner Cottage. The Ship Inn on the left had also been renamed; it was originally known as the 'Spread Eagle'. The scene today is very different. The Ship still plies its trade but the cottage has vanished to make way for road improvements.

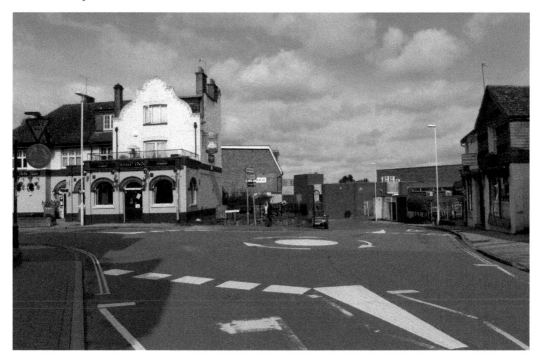

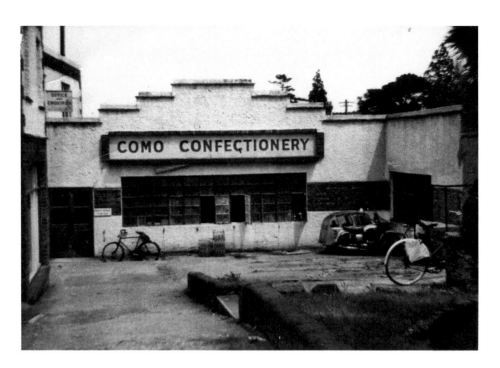

Como Confectionery

East Grinstead had two sweet factories at one time. One was on the Imberhorne Industrial Estate and the other was Como Confectionery, based on the London Road and a branch of a company in Regent Street, London. They specialised in children's sweets. Both ceased trading in the 1960s. The museum has in its collection two packets from this company. The whole row of buildings in this stretch of the road was levelled, and a Sainsbury's Homebase store now straddles the block.

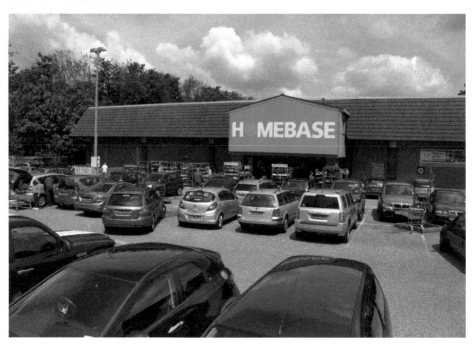

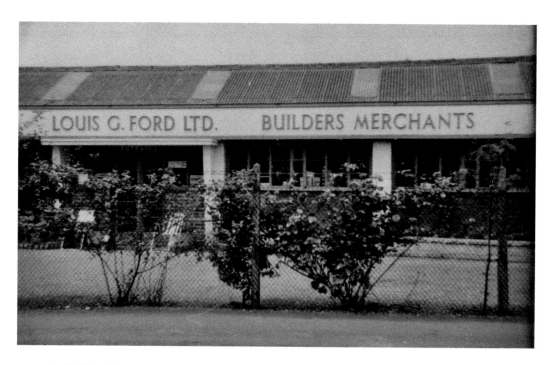

Louis G. Ford

A popular destination in the 1970s for professional tradesmen and DIY enthusiasts alike were the premises of Louis G. Ford in Brooklands Way. They sold a wide range of building materials and tools, as well as sundry items such as screws and nails. When they closed, the site was taken over by Sainsbury's. There is now a large and well patronised branch covering the whole area, the entrance to which is in Firbank Road.

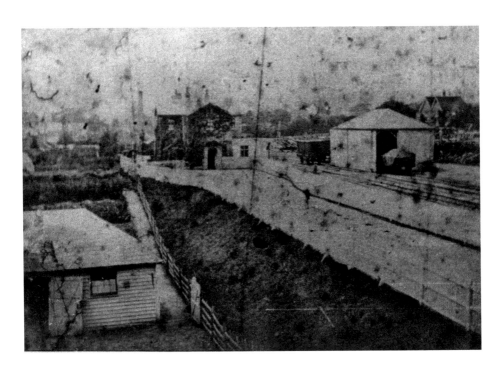

First Railway Station

The opening of the railway from London to Brighton through Three Bridges in 1841 took business away from the coaching route through East Grinstead. The town fell into decline and a group of local men were determined to build a connection to Three Bridges Station. They were successful, and on 9 July 1855 the first train arrived at East Grinstead. When the main line to London opened in 1881, another station had to be built, and it became redundant. It is now used as offices.

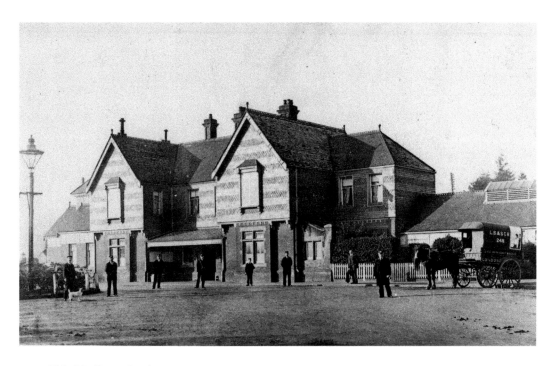

Third Railway Station

The original station served the line to Three Bridges. When the line was extended to Tunbridge Wells, another station was built to the side of it. This completely disappeared and no image survived. When the London line reopened in 1882, a completely new station was required as the lines were on different levels. The High Level served the Tunbridge Wells to Three Bridges lines and the Lower Level was on the line to London. It was pulled down in 1971 and its replacement was demolished in 2010. This station opened in 2012.

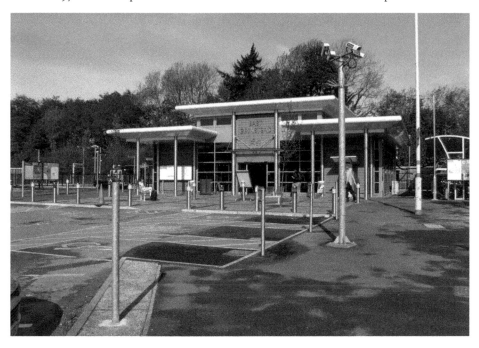

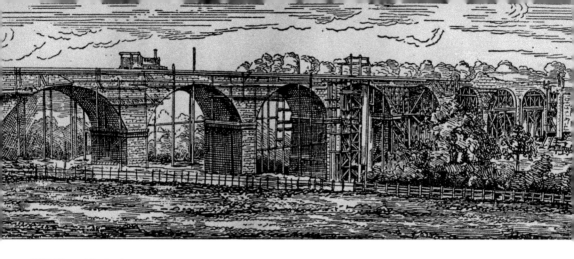

Hill Place Viaduct
The railway line to Lewes was laid in 1882. This viaduct carried the trains across the valley. The bricks were made from clay from the field below. The engineer was Joseph Firbank, who is commemorated in the road past the station. The line closed in 1958, and in 1960 the Bluebell Railway took over. The line only reached Kingscote by 1994. The amenity tip prevented the line reaching East Grinstead. Now removed, the magnificent sight of steam trains crossing the viaduct is again possible, making a dramatic entrance to the Gardenwood Estate.

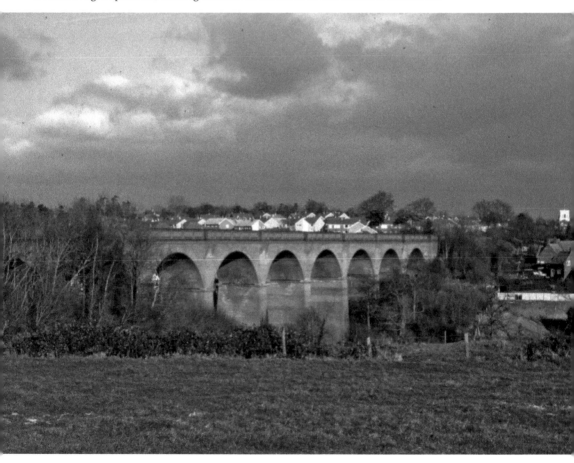

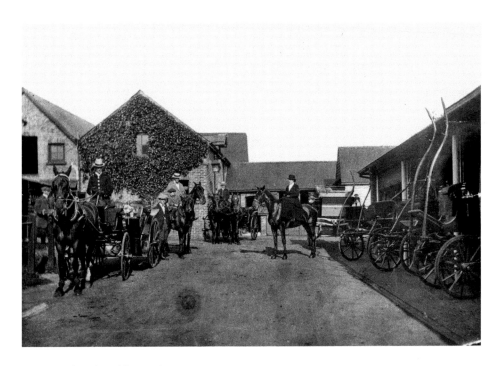

Nutt Brothers' Stable Yard

A busy scene at Nutt's Jobmasters Yard, Hunting Stables and Horse Cab Service in Station Road. The Nutt Brothers ran a thriving business. They owned landaus, broughams, victorias, a stage coach, twenty horses and a dog cart. They were contracted to supply horses to pull the fire engine when required. In 1905, they obtained a licence to ply for hire at the station. By the 1920s, Harold Nutt was running the site as a garage and car hire business. A service station is now there, on the one-way system.

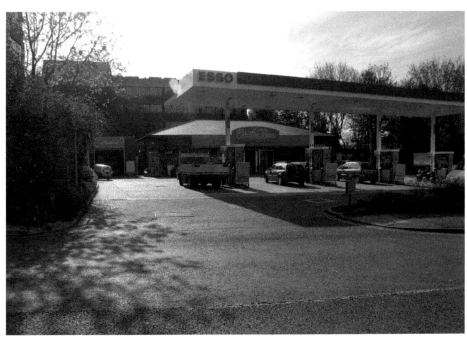

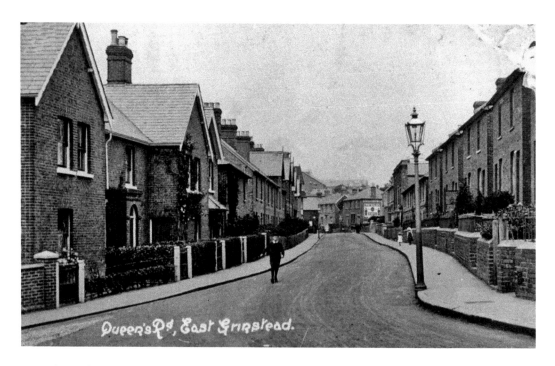

Queen's Rd, East Grinstead.

Queen's Road

This photograph of Queen's Road shows the entrance to the cemetery on the left-hand side. The road was originally called Cemetery Road, which the residents, understandably, did not appreciate. They took advantage of Queen Victoria's Diamond Jubilee in 1897 to alter the name. Today, these terraces have disappeared and the scene is mainly the car park for the shops near Queen's Walk.

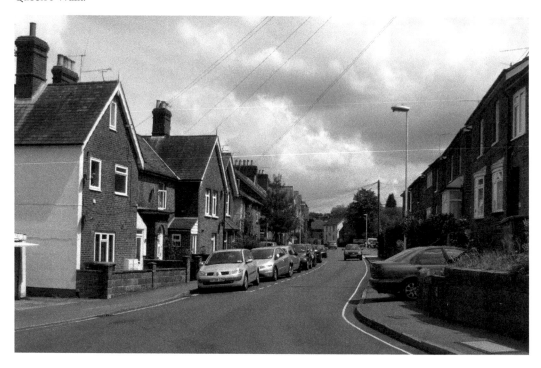

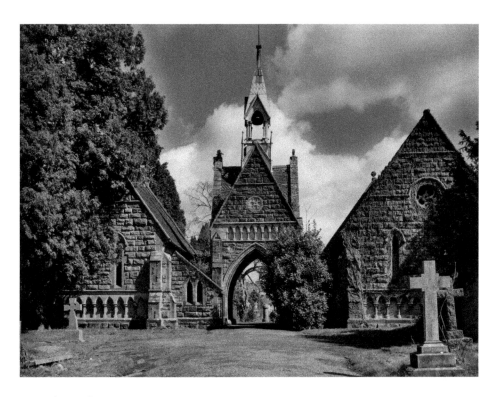

Queen's Road Cemetery

A cemetery was opened in Queen's Road in 1868, when St Swithun's churchyard became full. These twin chapels were erected, one for the Church of England and one for everyone else. It was sometimes called the Belfry. Now that it is full, burials take place at Mount Noddy. It is closed to the public on safety grounds, but application for access may be made to the East Grinstead Town Council. The grass is controlled by six sheep. The chapels are now residential dwellings.

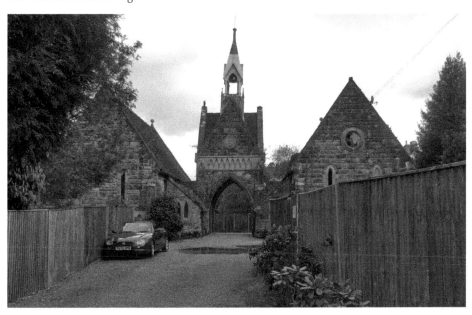

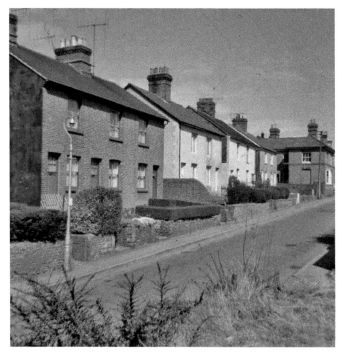

West Street

Looking up West Street, the former police station can be seen in the far distance. It was built in 1871 and was in use for nearly eighty years. A new police station was then opened at East Court in 1965. Iceland, the frozen food chain, now occupies this corner of West Street, although the entrance into the store is actually in Queen's Walk. Their storage and work areas behind the shop now stand where the police station once stood.

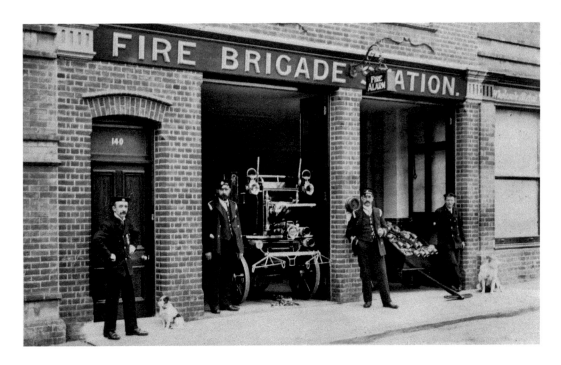

Fire Station

The town's first fire brigade was founded in 1863. Before that, two fire engines were kept in the church bell tower. The town's first purpose-built fire station was located at 140 London Road between 1906 and 1922. Posing for this photograph are Captain William Simmonds and three colleagues. The previous fire station was at 108 London Road, where the lookout window on the first floor can still be distinguished today.

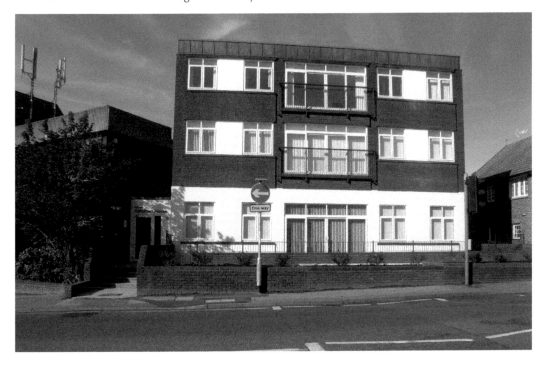

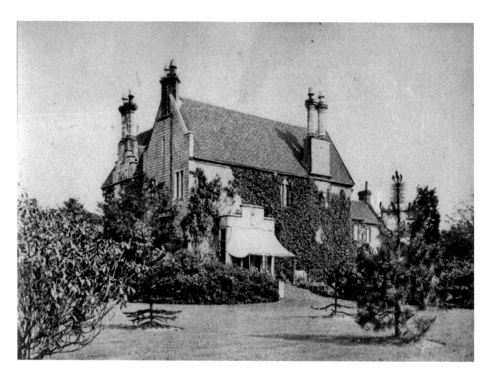

Vicarage

The vicarage for St Swithun's church was built around the time the church was repaired in 1880. A disastrous fire swept the building on the night of 27 February 1908. The firemen were impeded by the lack of pressure in their hoses, and this led eventually to the erection of the water tower which now stands in the Chequer Mead car park. The present vicarage shares its large garden with a small close of Georgian-style detached houses.

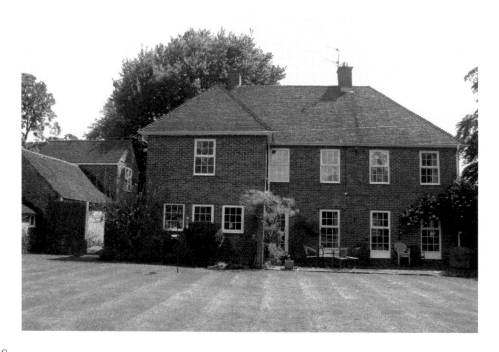

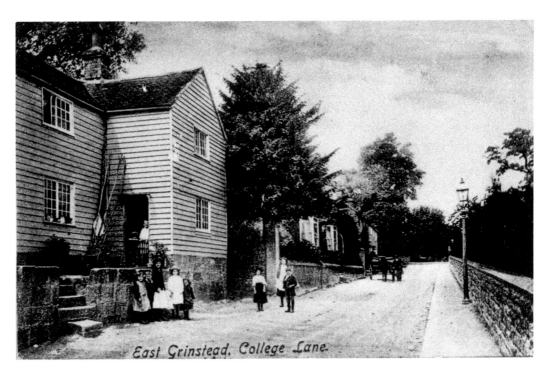

East Grinstead, College Lane.

College Lane

College Lane runs past Sackville College through Blackwell Hollow. The weather-boarded cottage is of a design more usually found over the county border in Kent. Together with the terrace of four cottages just beyond, it was pulled down in the late 50s. The site was partly developed in the 1960s. Finally, in the early part of this century the four cottages were replaced with another terrace of small dwellings. They are right against the bank behind, which is the Chequer Mead car park.

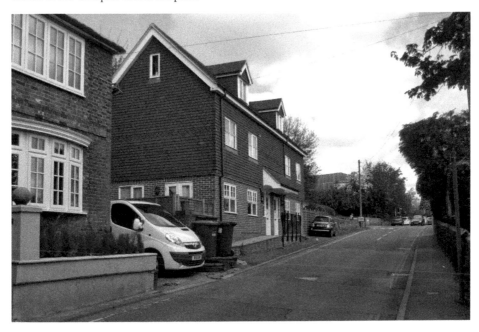

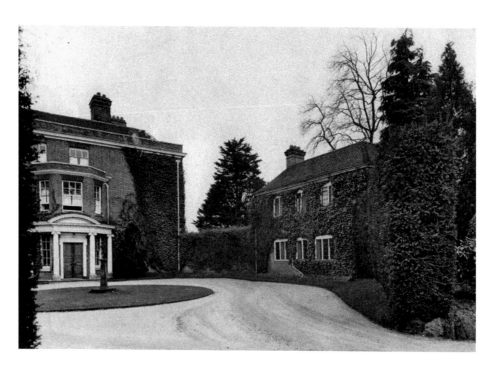

East Court, West Front and Stable Block, 1926

Built in 1769 for John Cranston, a London solicitor, East Court frontage originally faced east. The house was let to the Revd C. W. Payne Crawfurd for many years. After his death, the estate was sold to Ernest Cooper. He altered it so the house now faces west. It was requisitioned during the Second World War. Afterwards, it was purchased by Alfred Wagg and handed to the council, who remain its occupants. Rooms are available for hire. In 1999, the stables on the right were transformed into the Meridian Hall, another popular venue.

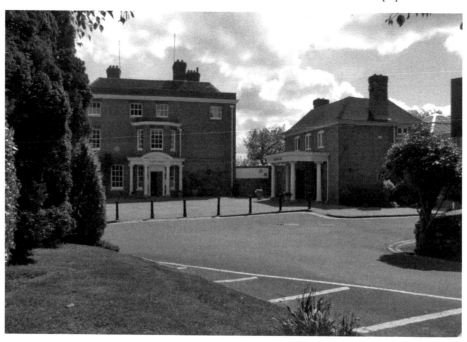

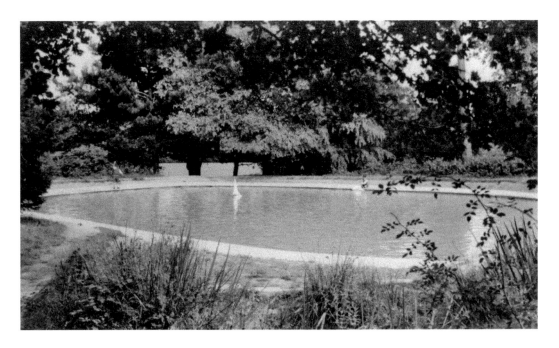

Boating Lake

Situated in the grounds of East Court, this lake afforded local children much pleasure sailing their toy yachts. The main Greenwich Meridian passes through the grounds. The pool no longer exists, but the grounds are still widely used for recreational purposes and are frequented by dog walkers. There are also tennis courts and in 2010 the Guides and Brownies of East Grinstead developed an interactive nature trail through the area.

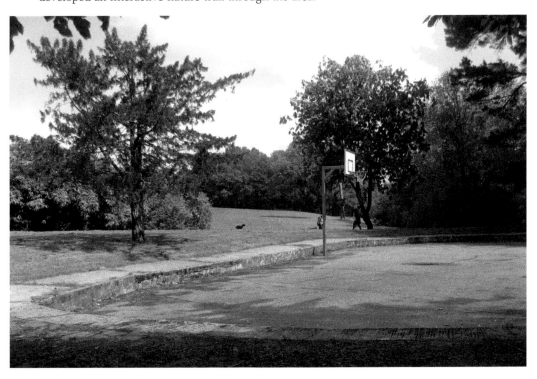

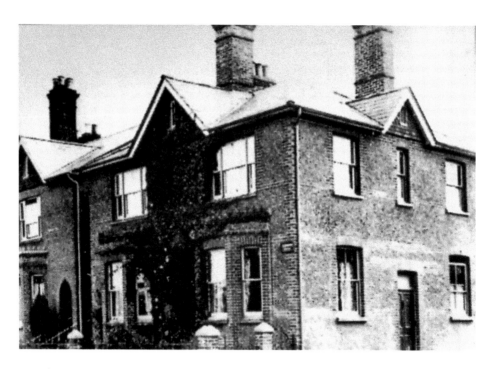

Lansdowne House

The first cottage hospital in East Grinstead was opened in Green Hedges by Dr Rogers in 1863. It closed after seven years as he felt unsupported. The need for a hospital arose when a groom had a serious accident. Public subscriptions and money left after the closure of the first hospital enabled the purchase of Lansdowne House. Later it was owned by W. H. Hills, a local editor and historian, who was also the chairman of the council. The building that replaced it is a branch of Carpetright.

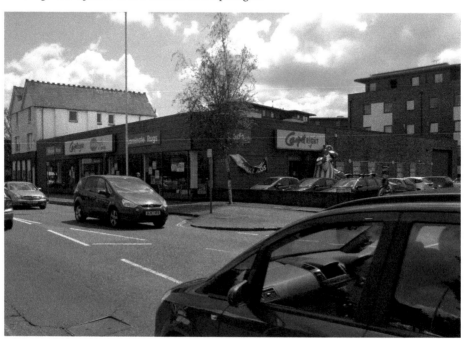

The Elephant's Head Coffee House
This building in Queen's Road was once
a coffee house. It later became a holiday
home for poor children from London.
When that closed, it was given by its
owner, Oswald Smith, to the Cottage
Hospital to replace the former premises,
which were now too small. It opened in
January 1901. At the end of the month,
Queen Victoria died. The hospital was
renamed in her memory as the Queen
Victoria Cottage Hospital. Known
affectionately as the 'Queen Vic', it is a
well-respected institution in the area.

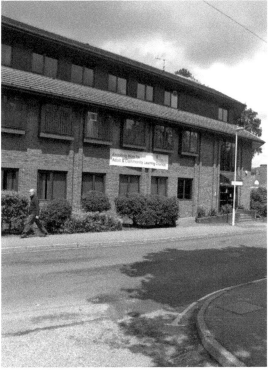

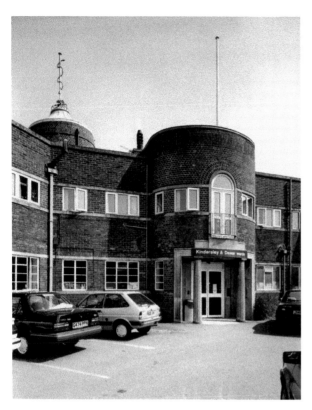

Fourth Queen Victoria Hospital
The original façade of the Queen Victoria Hospital. It shows the names of the two wards, Kindersley and Dewar. Sir Robert Kindersley gave the land on the Holyte Road to the Hospital Trustees. John Dewar donated £1,000 when the money raised was insufficient to pay for the new building. The larger hospital was officially opened in January 1936 by Queen Victoria's daughter, HRH Princess Helena Victoria. Their names have been erased as it is now called the Jubilee Wing.

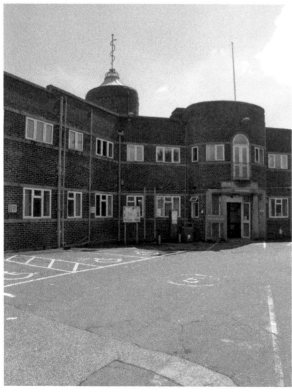

Guinea Pig Pub

Archibald McIndoe arrived at the
Queen Victoria Hospital in September
1939. His skill in treating badly-burned
air crew both physically and mentally
became legendary. His patients
called themselves 'guinea pigs', as
his techniques were pioneering. He
encouraged them to go out despite
their bizarre appearance. The pub
built near the hospital became a focus
for their social life. Here, admiring the
sign, McIndoe often served behind
the bar or played the piano. A block of
flats now stands on its footprint, but
the Guinea Pig name lives on.

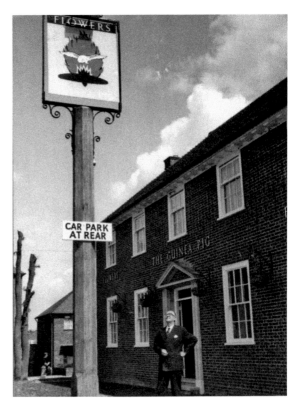

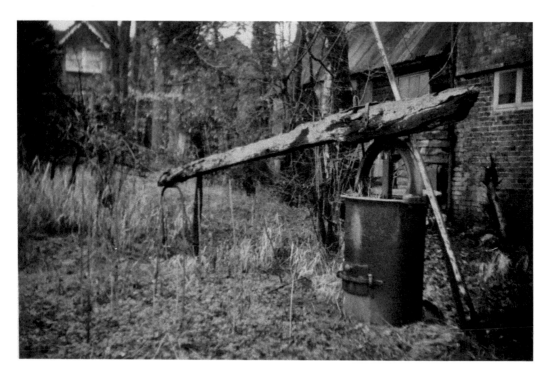

East Grinstead Pottery

Henry Foster founded the pottery in the eighteenth century. Most items were domestic earthenware. Butter coolers, dishes for animal feed and flower pots were churned out in hundreds. They also made decorative friezes, ridge tiles and finials for houses. The business flourished until 1942, when it was closed down because the fires made the town a target for German bombers. The site laid derelict for years. A local man, Charles Goolden, rescued many articles and presented them to the museum. The site now houses the offices of the Caravan Club.

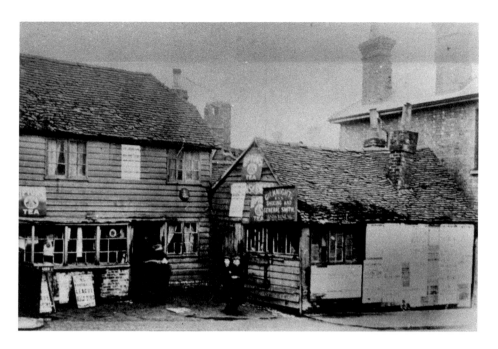

Forge

George Knight, shoeing and general smith, had his forge on London Road. This photograph was taken in 1910, four years before it was demolished. Forges were often on island sites because of the fire risk. The shop that replaced it for two years was called 'Ye Olde Sweet Shop'. It was then sold to Major's, the jewellers. This family firm, who were in business in the town for over 100 years, sadly closed its doors for the final time at Easter 2013.

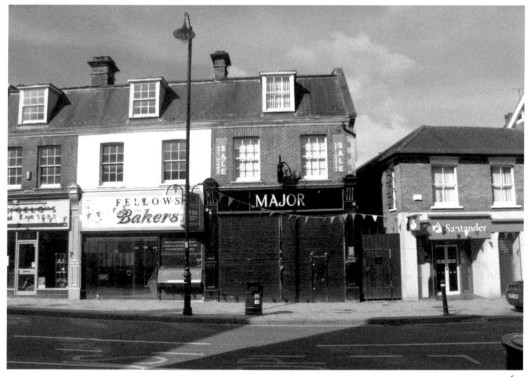

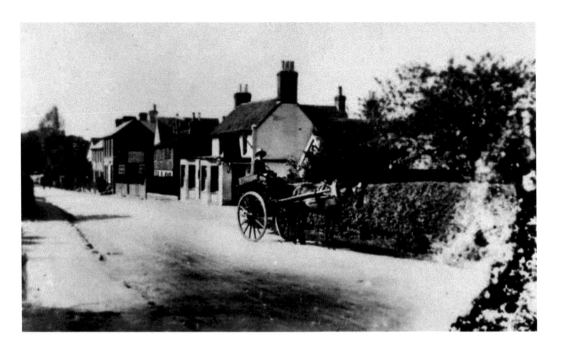

Lingfield Road

The horse and cart have just passed the Prince of Wales pub on the Lingfield Road, Baldwin's Hill. At that time, it was just over the county border, in Surrey. It was named in 1863, the year of the wedding of the Prince of Wales to Princess Alexandra of Denmark. The present building dates from 1890, probably built by the Southdown Brewery. It became part of West Sussex when sweeping changes were made to county boundaries in 1973, following the publication of the Maude Report. Today, the scene would be recognisable to anyone from that era.

Dormans Park Road

This view of Dormans Park Road was taken in 1980 while the East Grinstead Dairy still occupied the corner site shown here. Unfortunately, more and more people buy their milk in supermarkets rather than having their milk delivered. This proved to be the end for this dairy. They closed for business on 7 January 1995, and the site was taken over by McPherson's Glass.

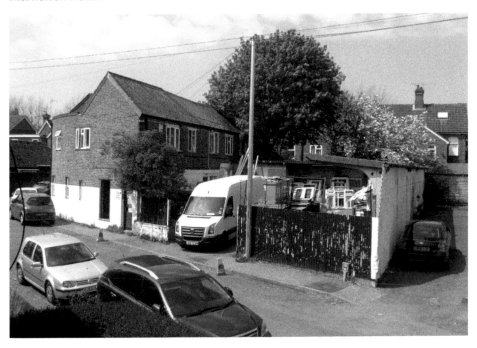

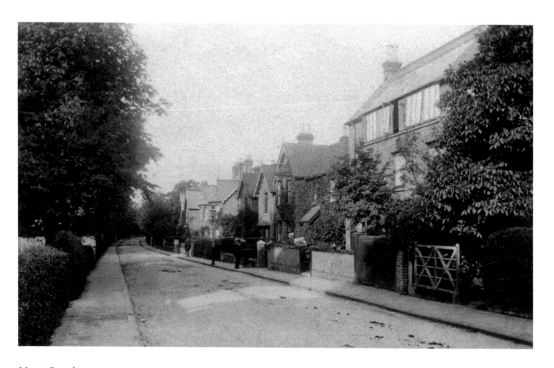

Moat Road

Past the bend to the right stood 'Oak Croft', the home of Mrs Dora Powell. She was a friend of Edward Elgar before her marriage, and is the 'Dorabella' of his *Enigma Variations*. No photograph exists of her house. The site is now occupied by a block of flats called 'Poels', the proper pronunciation of the name 'Powell'. The large, studio windows of the house of William Page, a local photographer, are visible on the right. One of his images has been used here.

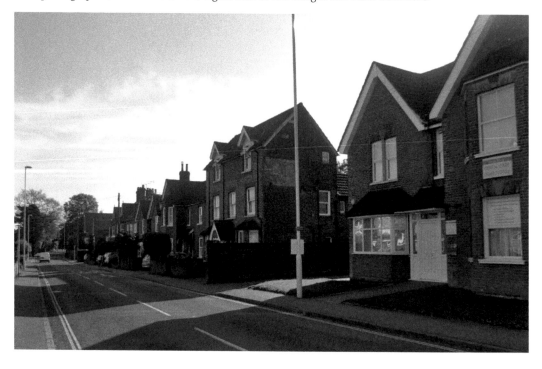

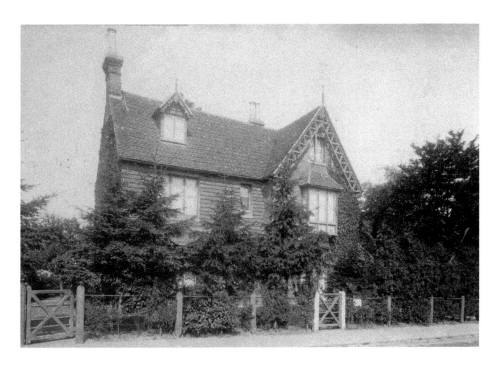

Moat House

The well-respected local solicitor, E. P. Whitley Hughes, lived in Moat House in Moat Road for several years. It was built before 1877, around the time the road was laid out. Hughes also served a clerk to the Urban District Council, the forerunner of our town council. He was the leading light of the town football team. A contemporary describes him as 'tall and strong with small feet. The way he dribbled was remarkable.' Today, modern houses are on the site.

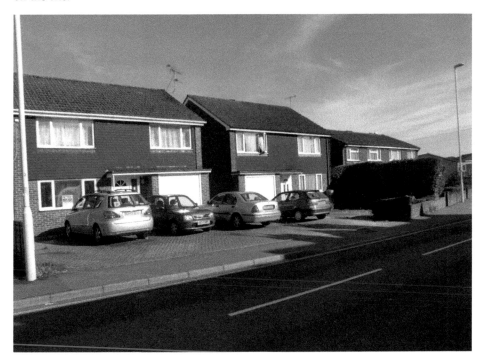

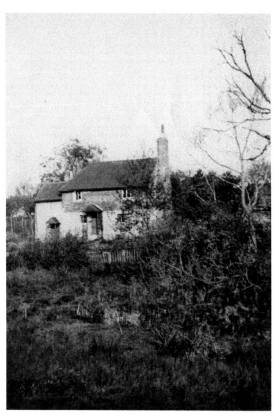

Blackwell Farm
This photograph, taken from the Holtye Road, shows Blackwell Farm House in the 1920s. Although it was first mentioned in 1594, it only survived two decades after the photograph was taken. It was one of the first areas to be developed in the town. The Blackwell Farm Estate dates from the early 1930s. Most of the other estates were not started until after the Second World War. Houses and a primary school now occupy the farmland.

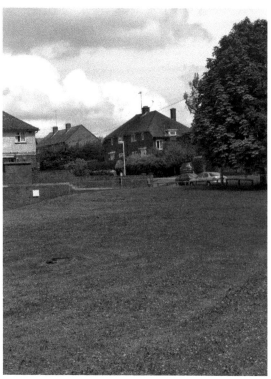

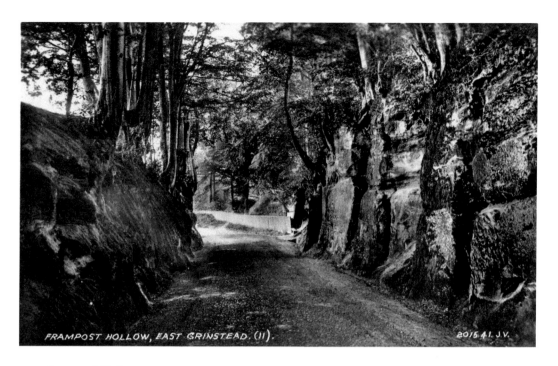

FRAMPOST HOLLOW, EAST GRINSTEAD. (II). 2015.41. J.V.

Frampost Hollow

This delightful view of Frampost Hollow was taken just before the Second World War. It shows a cutting through the sandstone ridge upon which the town is built. It would have been hollowed out by the passage of feet over the centuries. The church that stood on the highest point in the area was the focus for the inhabitants of the various manors recorded in the Domesday Book in 1086. The scene is still the same except for the addition of a car.

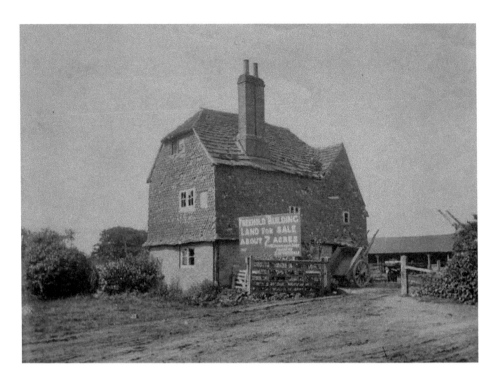

Copyhold Farm

The name 'Copyhold' suggests that this farm was built in the eighteenth century. Copyhold meant that rights to the land were given by the Lord of the Manor. The copyholder would be given a copy of the entry in the Court Rolls to prove his ownership. The building, obviously derelict, was demolished soon after this photograph was taken. Copyhold Road, built on the site, was originally council housing but most are now in private ownership.

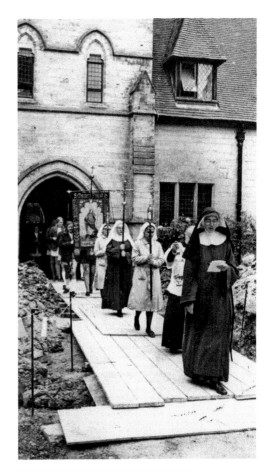

St Margaret's Convent, Moat Road
Built to accommodate the Anglican Sisters
of St Margaret, founded by the Revd John
Mason Neale, this convent replaced their
temporary premises in the High Street. They
were highly regarded in the community for
their care of the poor and sick, especially on
Ashdown Forest. This photograph was taken
in 1973. As their numbers dwindled in the
late twentieth century, the Sisters moved
to a smaller convent at Uckfield. The
buildings were converted into houses and
apartments, which retain many of the
distinctive architectural features.

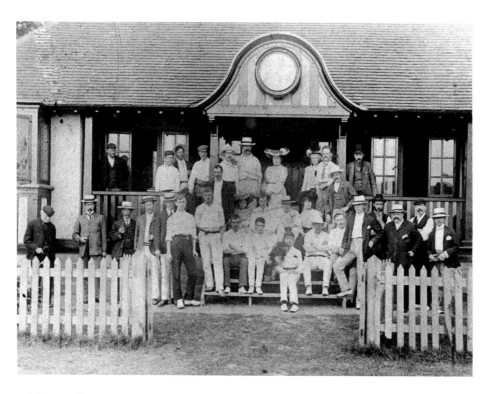

Cricket Pavilion

East Grinstead Cricket Club was founded in 1857; however, it was not until 1890 that they acquired their ground in West Street. When the inaugural match was played, tea was served from a marquee. Eleven years were to pass before they could afford a pavilion. The ground was sold for development and the pavilion was demolished. Its name lives on in Pavilion Way. Another road on the development is the cleverly named Dexter Drive, after the Sussex County cricket captain and his favourite stroke.

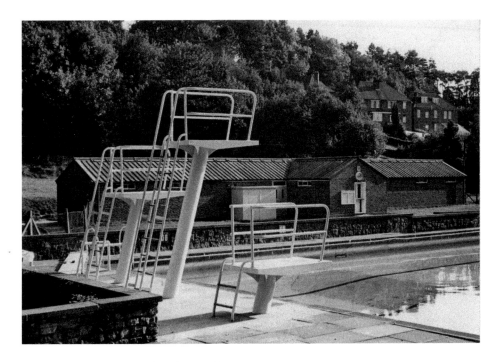

Brooklands Open Air Swimming Pool

This lido was a favourite summertime meeting place for families and children. It was sadly closed, much to the regret of local residents. The leisure complex in King George's Field, which replaced it, includes an indoor swimming pool. It is excellent as it is usable year-round, but is just not as much fun as Brooklands used to be on a hot, sunny day. This valley site is still valued for recreational purposes as it is now a public open space.

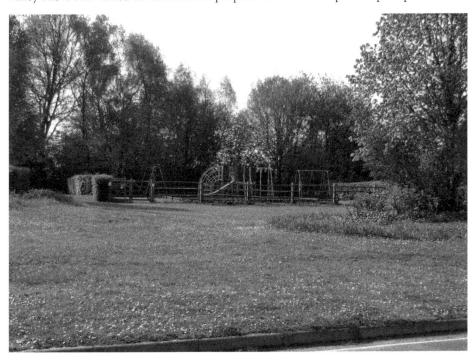

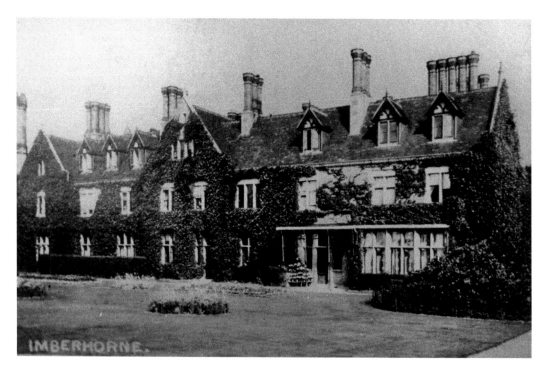

Imberhorne

Owned by the Blounts, a wealthy Roman Catholic family, Imberhorne was one of the large houses built when the advent of the railway made it possible for professional gentlemen to travel to London to work, yet live in the pure air of the countryside. Demolished in the 1950s to build the estate that now sprawls across its extensive former grounds, it is pictured here in its final days. Campbell Crescent is built over the footprint of the former house.

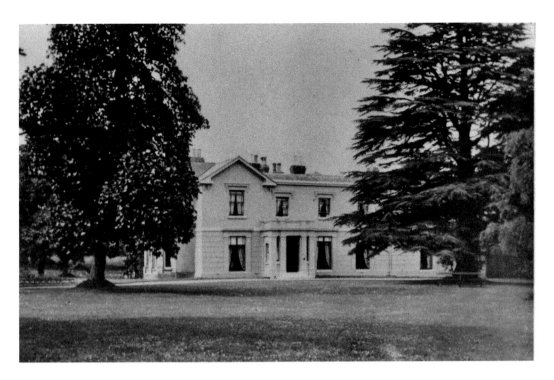

Halsford

This house was the residence of William Stenning, a local timber merchant. He was chairman of the Urban District Council for several years. His son, John, who was born in the house, wrote *Notes on East Grinstead*, the earliest written history of the town. Their family name is commemorated in the development off the London Road by the twenty-nine 'Bow Bells' milestone. Halsford was bulldozed and a large new estate built over the land in the early 1950s.

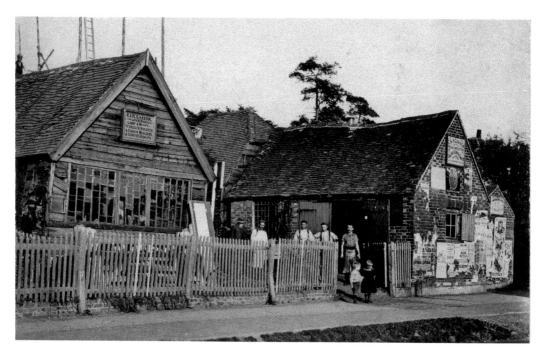

Gasson's Yard

This photograph shows the premises of C. & H. Gasson Ltd in the 1920s, who were builders and timber merchants. The two brothers, Clement and Henry, ran it for many years. On the death of Clement in 1939, the business passed to Clement's three sons, Arthur, Percy and Horace. It finally closed in 1980. Today the name over the door is different, but it is pleasing that the premises are still being used by builders' merchants.

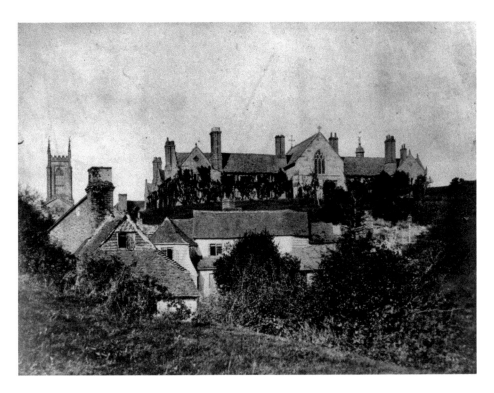

View Towards Sackville College

This view across the fields towards Sackville College and the church tower shows the cottages on the rocks, which were in Old Road. They have since been pulled down. It also gives a view of the eastern side of Sackville College, which cannot be easily seen today.

Kennedy's

These cottages stood in the front of Sackville College. Called Kennedy's in 1922 after the then owner, it was thought to spoil the view of the Jacobean Almshouses and was demolished in 1968. The present view shows that the decision was right. The magnificent Jacobean building was started in 1610. Robert, Second Earl of Dorset, left money in his will to erect an almshouse to shelter 'twenty one men and ten women'. It was completed in 1619 and still has the same function, although the accommodation has been updated.

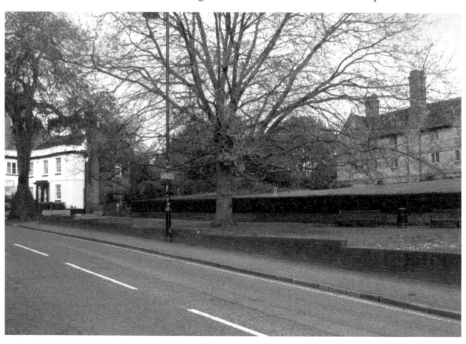

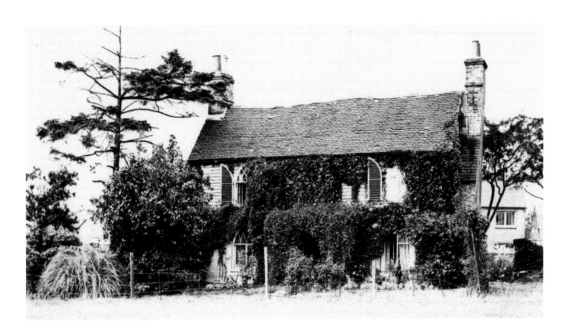

Shuckburgh Cottage

This charming cottage with Gothic windows stood on the eastern side of the London Road. It was named after Sir George Shuckburgh-Evelyn, its first owner, who was a well-known scientist in his day. In the 1871 census, this large house was occupied by just one elderly lady, Sarah Needham, aged eighty-seven. It was demolished in 1928. Today, no evidence remains of this house. It is an open space near the slip road to Beeching Way.

Southwick House

Near the corner of the Lingfield Road and the London Road stood Southwick House. It was purchased by the Urban District Council after the last war. The ground floor was converted for use as the public library, and opened for business in 1950. The upper storeys were used as residential accommodation. It closed in 1983, when more central premises were built in West Street. After the house was demolished, a block of flats was erected on the site. The name was retained for the new building.

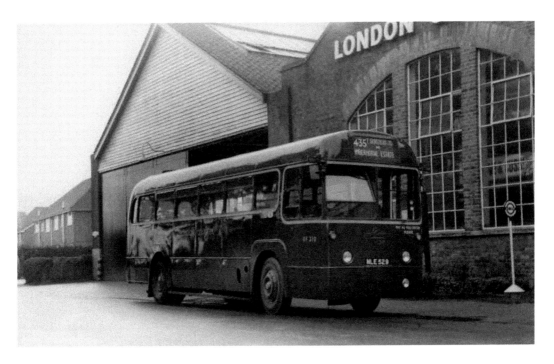

Garland Road Bus Garage

The London Transport Bus Garage was closed down before the bus services were privatised. Garland Road and the road running parallel to it, Maypole Road, are so-named because Halsford used to hold a May Fair in its grounds every year. When the land was sold for development, it was requested that the tradition be remembered in the street names chosen. A large block of flats with a penthouse now occupies the site.

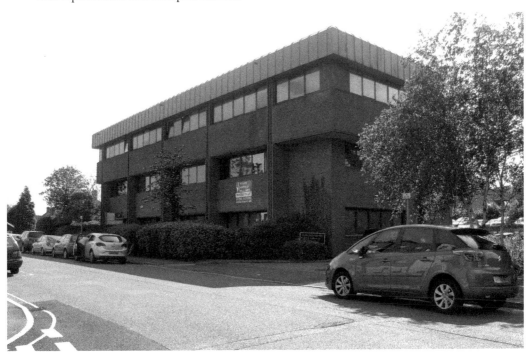

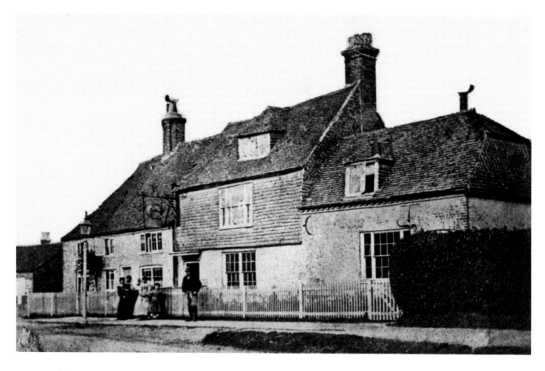

White Lion

The original White Lion was built in the sixteenth century on the turnpike road to London. At the edge of the common there would have been a steady stream of customers passing its doors. The Turnpike Trustees met there and the Bonfire Boys used it as their headquarters. This is an eighteenth-century building, which was demolished in 1965. It operated as a public house until the 1990s. It was then bought by McDonald's, who opened one of their drive-through fast-food outlets there.

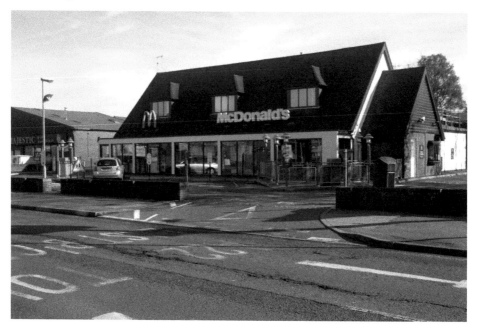

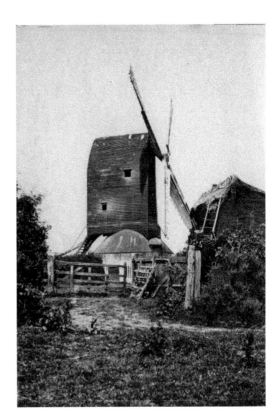

Windmill

There had been a windmill on the common to the north of the town for several hundred years. Most towns and villages would have had their own mills to produce flour from locally grown wheat. This post-mill was in operation until it was demolished in 1900. The house called Millfield, which was built on the land formerly occupied by the mill, has now itself been demolished. In its place is the new development pictured here.

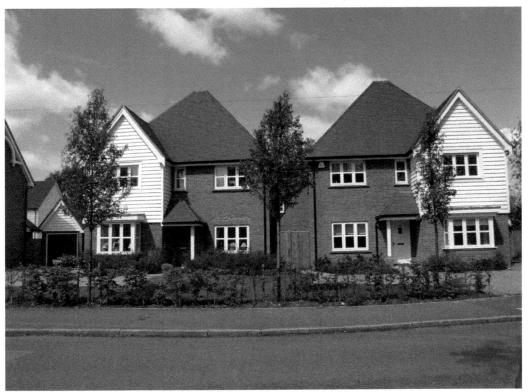

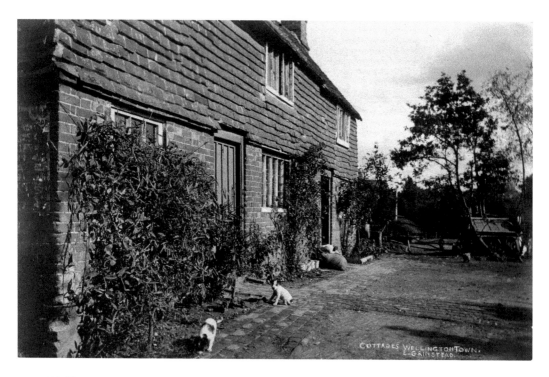

Wellington Town Cottages

This charming scene was taken around 1905. These cottages were built on the fringe of the common. It was not unusual for people to first put a haystack, then a fence, then a shed and finally a small cottage on common land. This practice, widely used in rural England, became known as 'thiefhold'. In this case, it appears that several cottagers must have co-operated to build this terrace. The area around the site of the cottages is now a small light industrial site.

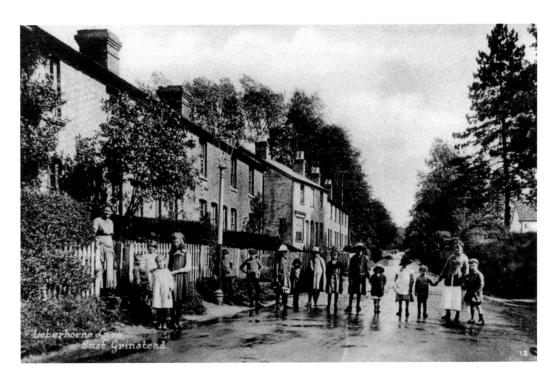

Imberhorne Lane

These cottages were in Imberhorne Lane, near the junction with London Road. It was in one of these that Sidney Godley VC lived. The 1891 census shows him living here, aged one. He won his Victoria Cross for defending a bridge at the battle of Mons. His commanding officer was fatally wounded and Godley carried on by himself until his ammunition ran out. He dismantled the gun and threw it in the river. He was taken prisoner and spent the rest of the war in Gemany.

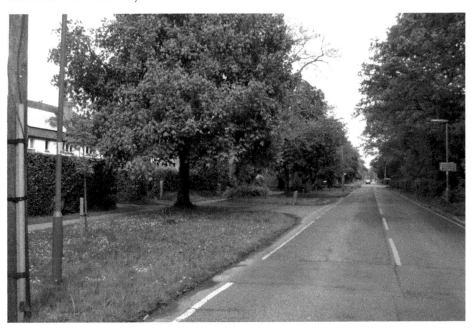

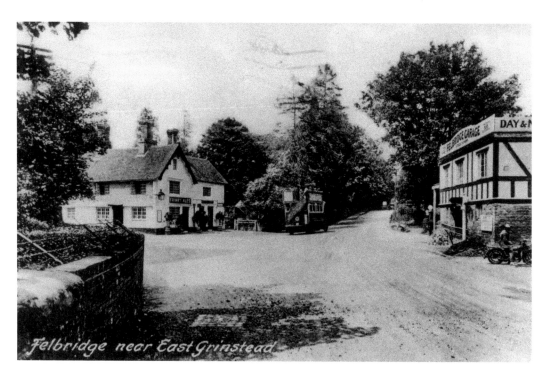

Felbridge near East Grinstead

The Star Inn at Felbridge

Records of the Star Inn, just over the border into Surrey, date back to the fifteenth century. The present building is thought to have seventeenth-century origins. The last toll-gate keeper at the northern end of the town was Mr George Worsell, who also ran the Star. The photograph below was taken in the 20s. It gives a very good idea of the lack of traffic in that period, when very few people owned a car. The inn looks very much as it has for centuries and is a popular place to eat.

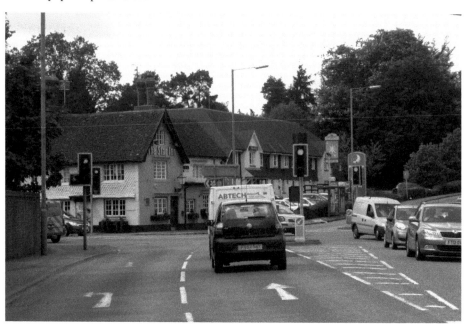

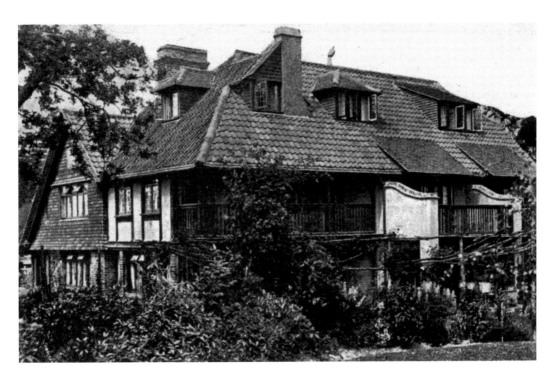

Felbridge Hotel

Despite its Tudor styling, the Felbridge Hotel was built in the 1920s. On the northern side of East Grinstead, it made a pleasant stopping place for those motorists going for a Sunday spin. A major portion of the hotel was damaged by fire in 1981. Since its rebuild, it has been greatly extended, but is still a convenient stop on long journeys along the A22. The surviving members of the Guinea Pig Club meet there for the AGM each May.

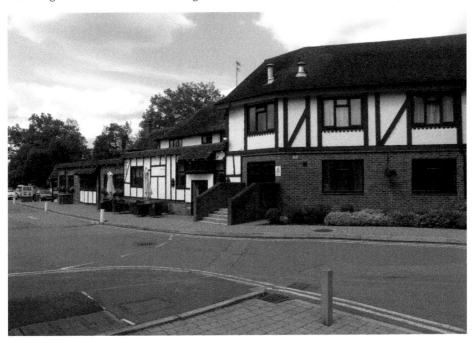

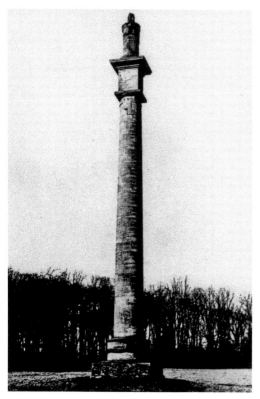

Evelyn Monument at Felbridge
This monument, dedicated to Sir John Evelyn, an important landowner in Felbridge, stood in a field opposite the present village hall. Over 65 feet high and made of sandstone, its future was threatened by an impending residential development. Sir Stephen Aitchison had it dismantled and transported to Lemmington Hall near Alnwick in 1928. Fortunately, the superb avenue of chestnut trees along the Crawley Down Road, also named for Sir John, still survives. Today, a row of houses of varied designs stands where an imposing pillar once commanded the view.

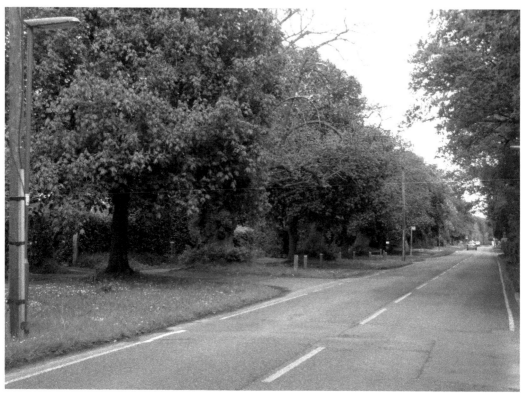

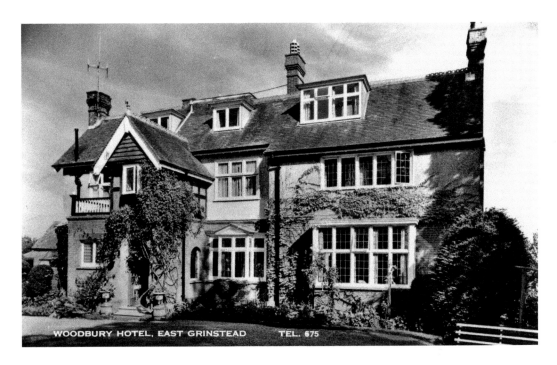

WOODBURY HOTEL, EAST GRINSTEAD TEL. 675

Woodbury House

Woodbury House was built in 1899 by the architect, H. E. Matthews, who also built several other houses in the area. It became a country house hotel in 1963. Standing on the Lewes Road just south of the town, it soon became a popular dining place for the residents of East Grinstead. Much to the regret of many people in the area, the hotel ceased trading in the early part of this century. It was subsequently converted into flats.

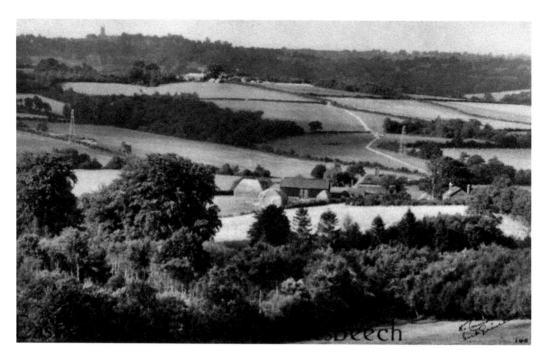

Whalesbeech Farm

This thriving farm was submerged when the valley was flooded to form the Weirwood Reservoir. This was to supply water for the new town of Crawley, created in 1955 to house the overspill from London. During the dry summer of 1972, the site became exposed and pottery was found dating from the thirteenth century. A flint flake suggested that Stone Age man had also once lived there. The reservoir provides a haven for wild birds and a sailing club which operates throughout the year.

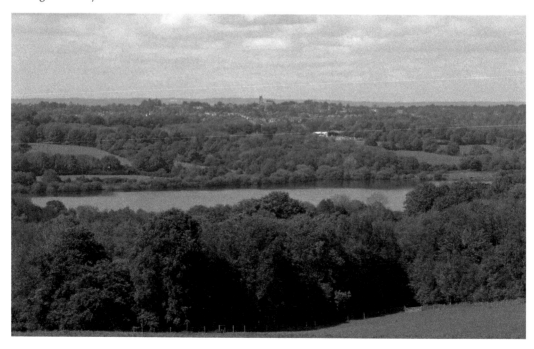

Bibliography

Dennison, E. J., *A Cottage Hospital Grows Up*
Gould, David, *East Grinstead in Old Photographs*
Gould, David, *Around East Grinstead*
Gould, David, *East Grinstead and its Environs*
Gould, David, *Through a Lens*
Hatswell, Dorothy, *East Grinstead, a History & Celebration*
Hills, W. H., *The History of East Grinstead*
Hounsome, T., *Three Pennyworth of Dark*
Leppard, M. J., *A History of East Grinstead*
Leppard, M. J., *100 Buildings of East Grinstead*
Mitchell, Vic and Keith Smith, *Branch Lines to East Grinstead*

COLIN MANTON

HAYWARDS HEATH

THROUGH TIME

OVER 400,000 COPIES SOLD
The No. 1 Best Selling Colour Local History Series

Haywards Heath Through Time

Colin Manton

This fascinating selection of photographs traces some of the many ways in which Haywards Heath has changed and developed over the last century.

978 1 4456 0902 7

96 pages, full colour